DATE DUE		
Aug 7/01.	OCT 2 0 2005	
APR 22 3 2004 APR 2 3 2004	NOV 1 4 2005	
NOV 2 2 2004		
DEC 1 4 2004		
JAN 2 7 2005		
FEB 1 7 2005		

The North Light Book of
Acrylic Painting Techniques

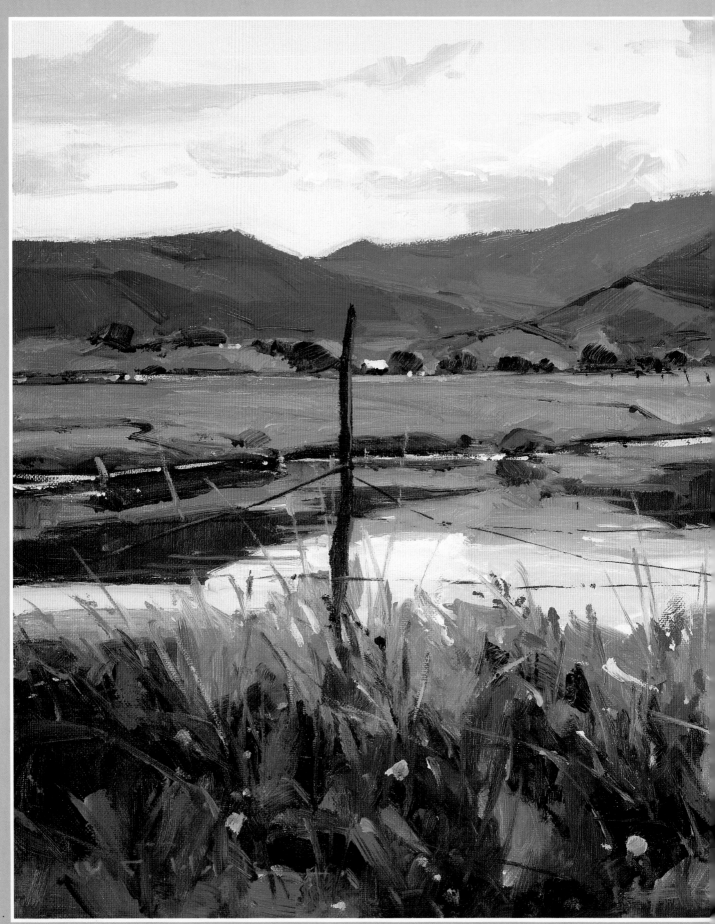

William Hook, *Stockpond*, 16"x20"

THE NORTH LIGHT BOOK OF

Acrylic

PAINTING
TECHNIQUES

EARL GRENVILLE KILLEEN

with Leah Raechel Killeen

NORTH LIGHT BOOKS
CINCINNATI, OHIO

ABOUT THE AUTHOR

Earl and Raechel Killeen moved from New York City to the Connecticut shore, where they live with their son Jared, one dog and three cats. Earl, an accomplished artist in many mediums, worked in oils, pen-and-ink, graphite and watercolor before embracing acrylics. His work has appeared in a number of publications, including several issues of *The Artist's Magazine*, where he received top honors in the still-life category of the 1992 national competition. Earl's immersion in art also extends to teaching, participation in a regional arts alliance and commercial illustration.

Raechel, an English teacher and tutor, also teaches a course in graphic design. She has written and illustrated a variety of educational materials, as well as several children's books. The Killeens have enjoyed working as a team on many writing and illustrating projects, and they share a love of beauty in its many varied forms.

The North Light Book of Acrylic Painting Techniques.
Copyright © 1995 by Earl Grenville Killeen, with Leah Raechel Killeen. Printed and bound in China. All rights reserved. No part of this book may be reproduced in any form or by any electronic or mechanical means including information storage and retrieval systems without permission in writing from the publisher, except by a reviewer, who may quote brief passages in a review. Published by North Light Books, an imprint of F&W Publications, Inc., 1507 Dana Avenue, Cincinnati, Ohio 45207. 1-800-289-0963. First edition.

99 98 97 96 95 5 4 3 2 1

Library of Congress Cataloging in Publication Data

Killeen, Earl Grenville
The North Light Book of acrylic painting techniques / by Earl Grenville Killeen and Leah Raechel Killeen.—1st ed.
 p. cm.
 Includes index.
 ISBN 0-89134-575-2
 1. Acrylic painting—Technique. I. Killeen, Leah Raechel.
 II. Title. III. Title: Acrylic painting techniques.
ND1535.K56 1994
751.4′26—dc20 94-22275
 CIP

Edited by Rachel Wolf and Anne Hevener
Designed by Sandy Conopeotis
Cover painting by Brad Faegre

METRIC CONVERSION CHART

TO CONVERT	TO	MULTIPLY BY
Inches	Centimeters	2.54
Centimeters	Inches	0.4
Feet	Centimeters	30.5
Centimeters	Feet	0.03
Yards	Meters	0.9
Meters	Yards	1.1
Sq. Inches	Sq. Centimeters	6.45
Sq. Centimeters	Sq. Inches	0.16
Sq. Feet	Sq. Meters	0.09
Sq. Meters	Sq. Feet	10.8
Sq. Yards	Sq. Meters	0.8
Sq. Meters	Sq. Yards	1.2
Pounds	Kilograms	0.45
Kilograms	Pounds	2.2
Ounces	Grams	28.4
Grams	Ounces	0.04

To Will Barnet, for his dedication and generosity as a teacher,
and for the warmth and dignity that have so often touched and inspired
those fortunate enough to know him and his art,
this book is dedicated.

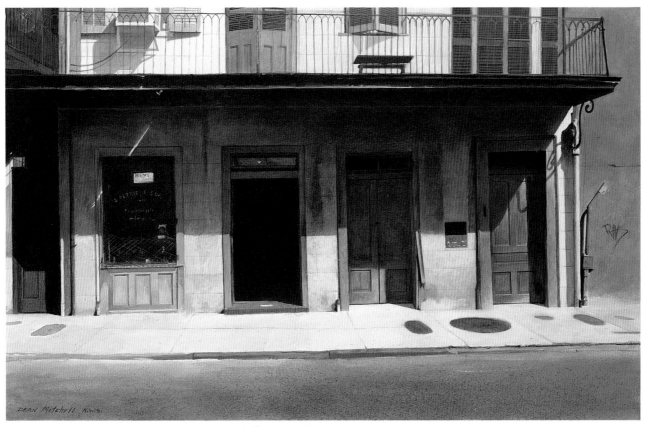

Dean Mitchell, *New Orleans French Quarter*, 18″ × 11″

ACKNOWLEDGMENTS

Heartfelt thanks to my gracious editors, Rachel Wolf,
Kathy Kipp and Anne Hevener, for their invaluable
collaboration; to Mike Ward for his encouragement; to
my photographer, Erik Redlich; and to Ferris Art Center
for the use of materials photographed for this book.

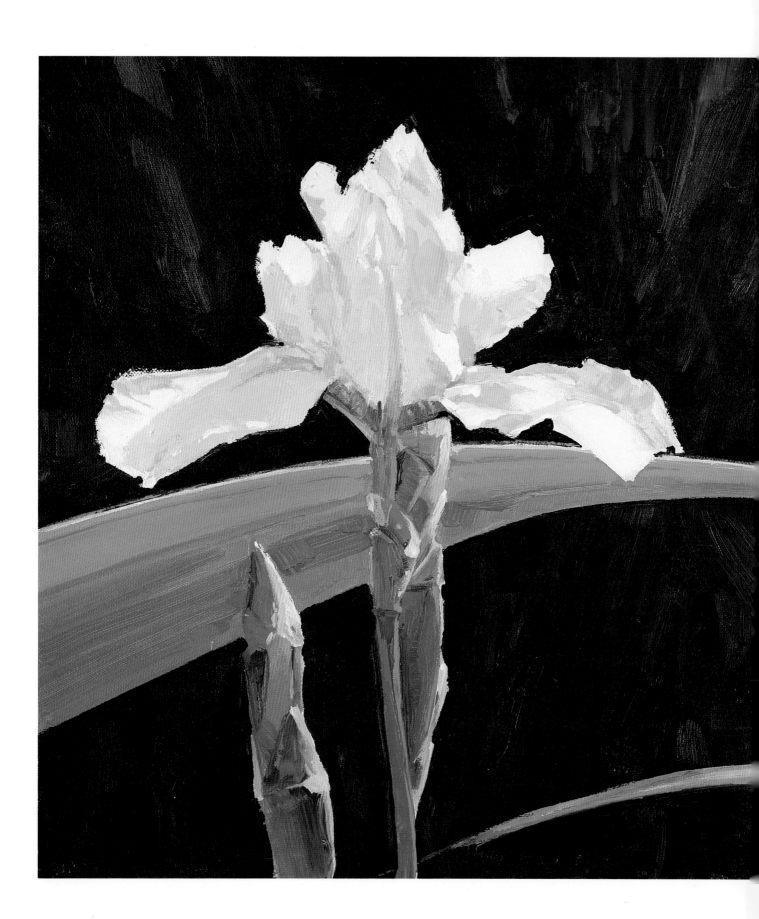

Introduction

W hat is acrylic? The dictionary tells us it is a glassy thermoplastic made by polymerizing methacrylic acid and is used in castings, moldings, coatings and adhesives. But as a painting medium, acrylic can best be defined as versatile.

An acrylic painting can resemble anything from a watercolor to an oil, though the techniques used in applying this medium are its own. With a great variety of brushes, as well as a palette knife, sponge, tissue paper or even your fingers, you can apply acrylic in any consistency ranging from thin washes to virtually sculpted impasto. It is workable on paper as well as fabric and wood. Acrylic can be used with a whole spectrum of techniques from glazing to crosshatching, including scrubbing, sanding, spraying, bubbling, collaging. You will see acrylic paintings in every style and genre, created in the studio or on location outdoors. To top off the list of acrylic's attributes, it is extremely durable and colorfast when finished, and it is correctable by a variety of methods at any stage.

It is a medium that provides challenges and rewards at every level of expertise. In this book you'll meet twenty-three artists who will share their skills, experience and joy in painting with versatile acrylics.

*William Hook, **White Iris**, 16″ × 20″*

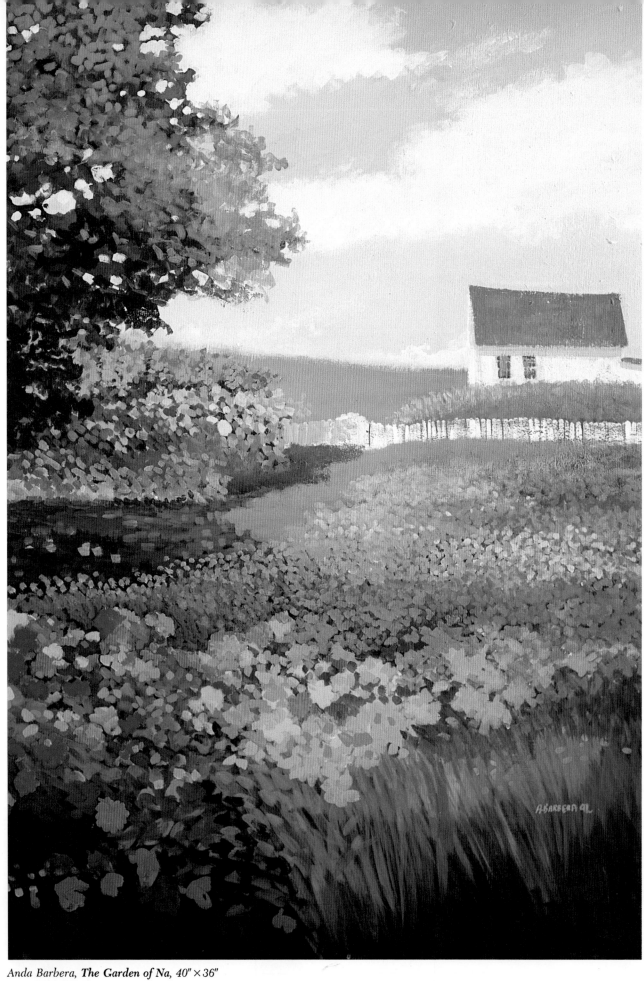

Anda Barbera, **The Garden of Na**, 40″ × 36″

CHAPTER ONE

Versatile Acrylics

A Medium for All Reasons

Although acrylic is one of the most versatile and popular media in use today, enjoyed by professional and amateur artists alike, there are still those painters who believe in the persistent myth: "Real" artists don't use that "plastic paint!" It is true that acrylic, with its polymer base, is still a relative newcomer to the painting scene, and that the last word cannot yet be said about it, but this responsive medium has been put through its paces by many a reputable artist, including those you'll meet on the following pages. These artists, painting in a variety of genres and styles, have demonstrated acrylic's very creditable qualities and range, and they have found the medium both challenging and refreshing. In the words of Robert Bissett, one of the book's contributors: "The very essence of any art form has always been to give expression to the self, the emotional being. For the poet, the composer, the writer and the painter, that has most often meant an expression of love for the subject and love for the work of art itself. Acrylics can be used in this age-old pursuit of enjoyment, mastery and inspiration as easily and successfully as any traditional medium."

I admit to being a late bloomer in the dynamic field of acrylic painting, having worked in traditional media for four decades. But now that my own artistic endeavors are immersed in this so-called unorthodox medium, I cannot understand why many artists believe that oil paint, for instance, is the last word in painting, as though the development of "new-fangled" media were not to be welcomed in the natural course of evolution. If such were the case, these artists might still be using the charcoal and ochre cherished by our Cro-Magnon predecessors.

Quite another quibble over acrylics is that it is a poor substitute for other media, such as watercolor and oil. True, perhaps; but, by the same token, egg tempera is not watercolor, which is not oil, which is not acrylic. Each is simply its own animal with its own unique blend of working and finished characteristics. And for those who have discovered acrylic, it is, in fact, one of the most versatile and enjoyable vehicles of artistic expression. One need only stop expecting acrylics to match or mimic other media to begin to appreciate its capabilities. As a master painter in acrylics, Robert Bissett has a simple philosophy for the beginner: "Use acrylics like acrylics—don't set yourself up for disappointments."

Acrylics are different from any other medium that you may have used in the past, and if you set out to use acrylics in the same old manner or with a particular preset work formula, you are likely to be disappointed. In saying this, I don't wish to sound discouraging by any means. Rather, I want to encourage the beginning painter in acrylics to approach the medium with an open mind and to expect a period of experimentation aimed at finding out what acrylics *do* and *don't* want to do. As you continue to pursue this intriguing painting medium, you will continue to discover and learn to manipulate yet another and another of its working characteristics.

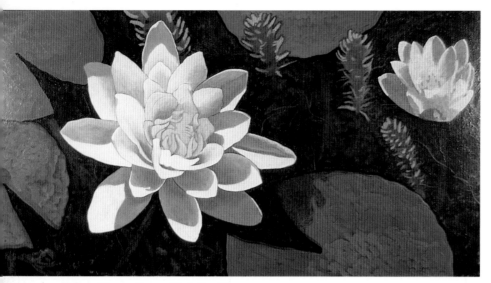

Robert Bissett, Lotus #2, 24" × 48"

ACRYLIC IS NOT WATERCOLOR. *Robert Bissett used acrylic to achieve luminous color and depth in this simple subject. He advises would-be acrylic artists to "use acrylics like acrylics."*

Getting Acquainted

Whether you're experienced in another medium or not, you'll find that acrylic will make demands on its user to think and work faster, and to plan ahead and solve problems, all of which can make you a better painter no matter what your current status. But jn wading into your first acrylic, it bears reiterating Bissett's advice to approach the medium as though you have never painted before. The fewer preconceived ideas you have, the less prolonged your initiation will be. This book, too, will ease your way, for it is designed to minimize the pitfalls the embarking acrylic artist might encounter.

I suppose one can say that the

*Earl Grenville Killeen, Detail of **Onanizmo***

A FIRST ATTEMPT. *My first attempt at acrylic painting was anything but fruitful. I mistakenly tried to do the old thing with a new medium. Through my lack of knowledge and my fear of the medium, I ended up with little more than the semblance of a paint-by-number project. Viewed up close, the lack of texture in the paint, as well as the flatness of the colors, betrays a fearful and cautious handling of the medium.*

*Earl Grenville Killeen, Detail of **Rhode Island Blue***

A LATER ATTEMPT. *A detail of another piece of blue machinery done fifteen paintings later exemplifies the look that I knew I was after. Patience and perseverance make the difference.*

adventure of painting in acrylic begins with that well-known "fear of the unknown." The first few brushstrokes—if not the first few paintings—can be somewhat unsettling. It may be reassuring to keep in mind that the artists represented on the following pages all took the same faltering first steps, and then went on to use acrylics successfully in a great variety of ways. Their techniques embrace the vast range of styles and surface qualities achievable with the acrylic medium. A browse through the gallery of our contributing artists will acquaint us with the diversity of the visions and methods they bring to bear as acrylic painters.

Blending for Flawless Transitions

Laura Anderson is one of the many artists in this book who for many years worked in both oils and watercolor before attempting acrylics on the friendly suggestion of her framer. She was first attracted to acrylics because of its fast drying time, an attribute cited by almost every artist in this volume as one of acrylics' best. It is certainly an asset to any artist who enjoys drybrush or glazing techniques. In Anderson's case, the subtle depiction of graduating tones that most interested her was a task that took many years to achieve. Of soft blended edges, Anderson states: "I think I maximize the strength of acrylics by layering and modulating the colors with even brushstroke and scrubbing techniques. My aim is for a pure, 'brushstroke-free,' yet modulated color. My strongest interest in painting is to paint light and subtle nuances that occur in light and shadow. I do not want visible brushstrokes to interfere with my portrayals."

Laura Anderson, **Top Deck**, 18" × 14"

SOFT, BLENDED EDGES. *Many years of practice are behind the serenity conveyed by Laura Anderson's brushstrokeless passages.*

Drybrush for Texture

William Hook relies on the "loaded" brush and its consequent texture, which becomes a target for drybrushing as opposed to blending. Whereas Anderson maintains a large quantity of fan brushes that aid her in achieving flawless transitions of value and color, Hook will often execute an entire painting with a no. 10 bright, taking advantage of every plane, edge or corner the brush has to offer. To Hook, the brushstroke is the life of the painting.

In working fast, Hook aggressively uses the favorite attribute of acrylic—its fast drying time. Usually working on a large canvas, he is able to block in entire sections at a time, working them almost to completion and then blocking in juxtaposing areas. He is not "distracted" by detail work until the final stages of the painting, allowing him to keep his eye on the "whole." In the later stages of his process, he starts pulling and pushing the painting's lights and darks, opposing or sometimes marrying his light with shadow.

*William Hook, **Reflected Evening**, 36″ × 36″*

RICH TEXTURE. *This painting shows William Hook's passion for the brushstroke, the textured and vibrant passage. This makes for a perfect marriage between this artist and the acrylic medium, which allows him to work an area over and over in a matter of minutes.*

Layering With Thin Washes

Nina Favata's work is, in its way, an example of one end of the acrylic spectrum. Acrylic can be worked in consistencies ranging from thin washes to impasto; Favata, working on paper, dilutes her paints to a consistency close to that of watercolor. Yet, unhampered by the limitations of that medium, she is able to glaze color over color without disturbing paint laid down in any previous layer. By avoiding the unintentional mixing of colors that plagues the watercolorist, she is able to retain a "clean and simple" imagery.

Favata sums up her experience with acrylics by noting, "Though it is always best to experiment with other media before you settle down to one, I feel acrylics are the most versatile by far and easiest to use. The results you can achieve are endless."

Making Corrections

Another aquamedium specialist is Arne Lindmark, a fine-art watercolorist who discovered acrylics while doing commercial art. Like Favata, Lindmark also works on paper, using masking tape, razor blades and tissues to control his values. He likes to work his values up from the darkest to the lightest, masking off areas that he planned from the outset to be lighter. If he should make a mistake — that is, should he get a particular area darker than he had intended — he uses a method of correction that departs from that of Favata. Whereas she washes over errors with white and repaints, Lindmark will actually razor-blade out the offending section by cutting around its perimeter and lifting off a layer of paper, exposing a new white surface to be freshly tinted.

Nina Favata, Sagamore, 28″ × 30″

SAFE EXPERIMENTATION. *Nina Favata is not one to be stuck in a rut. She has painted and experimented in many media. She finds that the acrylic medium affords her more elbow room for safe experimentation on many types of supports, which achieved great results in this painting.*

Arne Lindmark, Spare Parts Department, 22″ × 30″

AN AQUAMEDIUM SPECIALIST. *Arne Lindmark's work demonstrates the stability and the versatility of the acrylic medium. Using acrylic as a base layer, Lindmark introduced layers of watercolor to heighten or lower the chroma and value of his colors.*

Mixed Media

Because the acrylic formula is so stable in its chemistry, it is possible to use it in certain mixed-media applications. One such marriage of methods is evident in Dean Mitchell's work, which uses acrylic in conjunction with watercolors.

Well-versed in oil painting, Mitchell found — while working as an illustrator — that he was hindered by the long drying time of oils. He decided to try his hand at acrylics. Using the paint thinned to the consistency of watercolor, he takes advantage of acrylics' "hard-edge"

possibilities by employing the techniques of pointillism and crosshatching. Eventually, he brought the new medium into his fine art.

Working on gessoed board, he first applies a mixture of watercolor and matte medium. Next is an application of opaque acrylic, followed by a further application of the watercolor mixture to soften the effects of the acrylics' "hard" appearance. Mitchell still very much enjoys his oil paintings as well as his acrylics, recognizing that neither is a replacement for the other.

Dean Mitchell, **Bathed in Light,** *18″ × 28″*

SOFTENING HARD EDGES. *Dean Mitchell's use of watercolor is generally confined to taming acrylic's sometimes harsh appearance. By overpainting with watercolor, Mitchell turned a hard-edged painting into an invitingly soft image.*

Using an Airbrush

Another unorthodox practitioner is Phil Chalk, who applies acrylic paint with an airbrush, a technique that has not (yet) found universal acceptance in the fine-art world. But the properties of acrylic make it well-suited to airbrush application, and Phil Chalk is an exceptionally adept wielder of this hi-tech tool.

As most artists would agree, using the best materials is essential for best results. But because of a cheap grade of paint, Chalk's first experience with acrylics and airbrush was anything but fulfilling. With perseverance, Chalk explains, "what began as an exasperating method of painting developed into a technique I have become dedicated to over the last fifteen years."

For ease and dependable flow, Chalk formulates his paint mixture by using one part paint to three parts matte or gloss medium (usually Liquitex) along with eight to ten drops of Winsor & Newton acrylic flow improver. Not only does Chalk rely on different brands of paint for the effect he wants, he uses quite an assortment of papers, including 140-lb. cold-press watercolor paper, such as Fabriano Artistico and Waterford, as well as Strathmore Gemini, each of which affords him differing textures and degrees of durability; and, more recently, Strathmore four- or five-ply #500 Bristol (vellum surface) mounted on ⅛" untempered masonite.

*Phil Chalk, **Splash**, 25" × 40"*

AIRBRUSH APPLICATION. *This work dispels the idea that acrylic is strictly a hard-edged medium. With airbrush and colored pencils, Chalk is able to take the medium across the gamut from sharp- to soft-edged, and anywhere in between.*

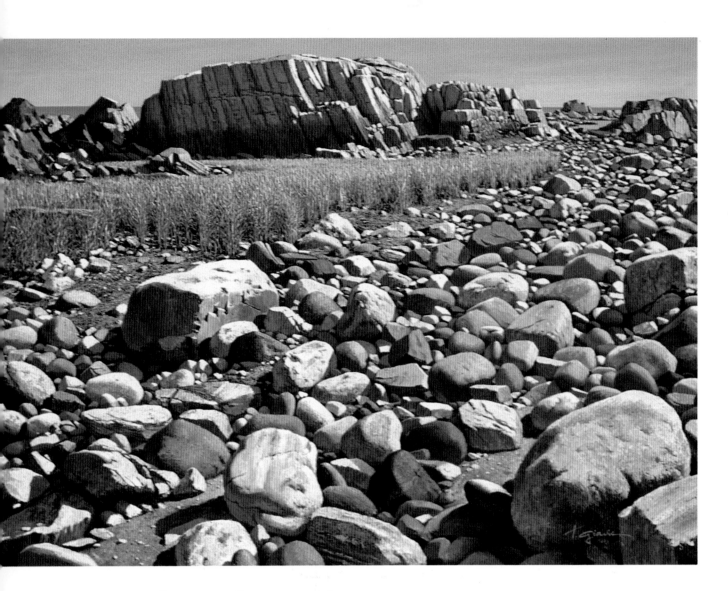

Using a Palette Knife

A favorite tool of the impasto painter is the palette knife—a useful item even for the brush aficionado. One artist who uses the knife as his *primary* tool is Ted Giavis.

Giavis first discovered acrylics as a commercial artist. Giavis' method of execution relied heavily on designer gouache, but while he was working on a car advertising campaign that demanded a smooth, crisp, tight, almost photographic appearance, a colleague suggested he try acrylic. Giavis took the plunge, but found that his first experiments with the medium left a streaky, uneven tone. Some time later, when confronted with an assignment that

seemed too overwhelming for his gouache technique, Giavis decided to unmothball the acrylics and try once again, this time using a palette knife. Much to his delight, it was "just what the doctor ordered," and the completed work was met with great enthusiasm by the client. Of his earlier attempt, the artist had this to say: "Acrylics can be tried by a person for the first time, and they may experience the same reaction I did. But as time went on, I made a complete turnabout with this medium."

Giavis centers his art on his childhood playing ground, the New England shore. "Most of my paintings

*Ted Giavis, **New England Rocks**, 33″ × 45″*

POWERFUL, TEXTURED EFFECTS. *Ted Giavis often paints the rocky coast of the New England shoreline using a palette knife to achieve varied effects. With this tool, Giavis can separate the sharp, jutting reality of the rocks from the softly brushed sky and water.*

are about 80 percent rock and shore with just a sliver of ocean and sky. Because the rocks appear powerful and strong in their shapes and texture, I feel that painting with a palette knife and a fairly good body of pigment displays that strength when applied to the canvas. The brush doesn't seem to give me that effect."

Taking Acrylics Outdoors

For the beginner, or for any artist living in an arid climate, taking acrylics outdoors may be a daunting undertaking, for the combination of wind and sun are apt to accelerate acrylics' celebrated fast drying time to the point of frustration for the painter. California's Geri Keary is one of those daring souls whose love of the water and light overrides her sense of caution, and out she goes with her easel. But her camera and sketch pad are never far away. Often she will start work on-site and—armed with photographs, sketches and color notes—finish her work in the studio.

For Keary, the rapid drying of the paint when braving the elements *en plein air*, as well as the initial struggle to use the medium in her impressionistic style caused some setbacks. Keary tackled the drying problem with the judicious use of a spray bottle to keep both her paints and her painting moist, and with a deep-welled muffin tin in which her colors did not readily evaporate. But she found, too, that a combination of a good teacher and learning to use washes helped her to feel very much at home with acrylics. About this, Keary says: "Acrylics can be a forgiving medium. You can paint over mistakes and even make drawing corrections. Many painters I know use acrylics as they would oils, working thin-to-thick and completing the painting in one day because they do not have to worry about the drying time."

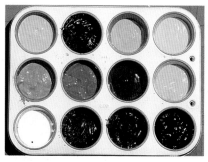

PALETTE

Geri Keary's palette is a muffin tin containing colors thinned with water. When she is done painting for the day, she covers the tin with plastic wrap and slips it into a plastic bag.

STEP 1

Keary tones her support with orange, then draws her images with red and blue.

STEP 2

After adding dark values, colors and reflections, Keary stands back to evaluate her painting. She asks herself how the color is working and whether there is a good sense of design.

STEP 3

Keary starts defining and balancing elements, and making corrections. She straightens the lines in the background buildings and changes proportions in some of the boats. The sailboat on the left is made larger because its size does not match the perspective plane it occupies.

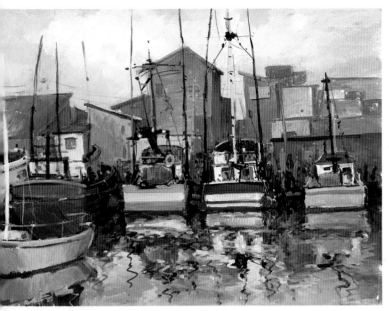

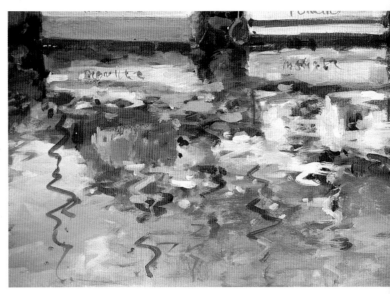

STEP 4
With the corrections handled to her satisfaction, Keary starts overlaying more color and darker values.

DETAIL
This detail of the finished painting demonstrates Keary's confidence in her handling of the medium. The playfulness of the reflections hints at the artist's enjoyment of painting.

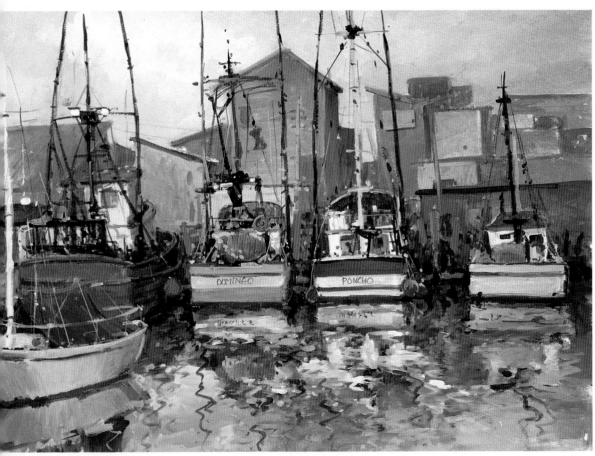

Geri Keary, **Domingo,** *22″ × 30″*

FINISH. *In the last stage of painting, Keary pays particular attention to where the eye will fall and how it will move when viewing her picture. A little "calligraphy"— some trolling poles, masts and lines— add interest and direction. A few bright spots for points of interest coupled with the reflections riding the water's current guide the viewer's eye through the picture.*

Accepting the Acrylic Challenge

Mark Jacobson, like Keary, branched out from oils to acrylics, though oils remain his medium of choice. In his acrylic work, he uses the traditional oil-painting methodology of building up his paint applications from thin to thick.

Keary and Jacobson are among the majority of acrylic artists who have a past with other media from which they've had to make a transition. And almost all painters in acrylic struggle with these paints in the beginning — some even develop a love/hate relationship with the medium. As Mark Jacobson puts it: "Acrylic has one very strange, very unique trait, which can be maddening. Unlike oil, tempera, watercolor or even casein, acrylic has a rather 'soul-less' feeling to me. It doesn't have any 'personality' — which seems to already, somehow, be present in oil paint or tempera. But that's exactly why I'm drawn back to it. It's the challenge of trying to breathe 'life,' to breathe 'resonance' into an otherwise rather impersonal 'plastic,' that keeps me sitting at the easel hour after hour. It's that challenge that will hopefully, someday, allow me to reach a high level of intensity, a sharpness and 'hard-edged' truth, which is a little bit too easy to smudge over, or just blur out, when you work in oils alone."

*Mark Jacobson, **Ghost Distance**, 30″ × 44″*

VALUE CONTRASTS. *Mark Jacobson has established mood through deep contrasts of value. Although his first love is oils, he finds acrylics very challenging and engrossing.*

Painting in the Thick of It

William Hook, as discussed earlier, is an artist who likes to take acrylic to its thickest. His finished paintings can be easily mistaken for oils, though the artist enjoys the greater fluid spreadability of acrylic. His clean-cut solid masses can give the impression that they are simply and cleanly applied, almost with single strokes. The finished simplicity of Hook's imagery is, however, very deceptive. Working with tube color and a little water, Hook starts out with thin washes, carefully building layers and glazing. He cautions students that using an initial heavy layer of paint can be quite frustrating when you attempt to layer other colors over it.

Hook relishes the fast drying time of acrylics, stating that it makes the artist think faster and react on a gut level. First impressions, he says, are probably the right ones. He strongly believes that mistakes are a reliable teaching method—but only to a point. If the mistakes a student makes become a frustration rather than a learning tool, the student should seek a qualified instructor.

Because of extreme arid conditions, Hook is not able to paint outdoors, nor does he suggest the novice try to. Although a spray bottle of water can retard drying time of the paint on both palette and support, Hook reminds us that a buildup of water in the paint mixture can be destructive. Hook uses Liquitex because it has a slower drying time. Like many acrylic artists, Hook finds that the trick in working with this medium successfully is to "make the shortcomings the benefits."

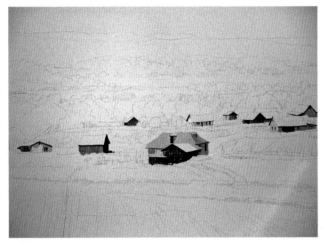

STEP 1

William Hook begins with a sketch in water-soluble pencil that won't show through his paints. Over the sketch, he starts painting in the center of his canvas, using colors of a middle value. Once his middle tones have been established, he works in his darks and lights.

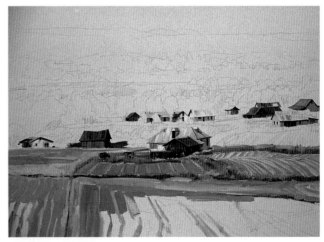

STEP 2

Hook finds that establishing the patterns of the fields early will allow him to keep going over them, building an impasto effect.

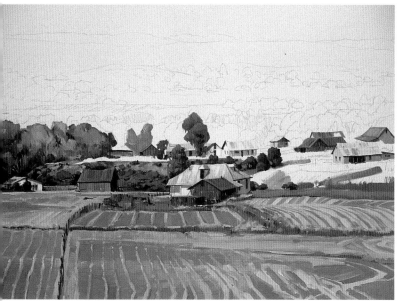

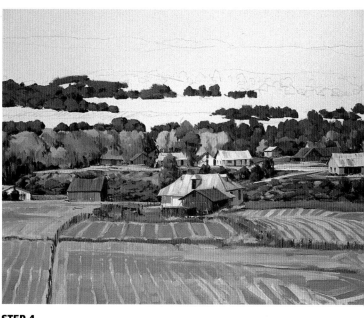

STEP 3
Now that the entire foreground has been blocked in, Hook begins laying down his background and establishing his light source so he can start playing with shadows.

STEP 4
The trees form a backdrop behind the village, and the contrast of values draws the eye to the focal point. Many of the buildings have new tin roofs that reflect light, so that "the town will come alive."

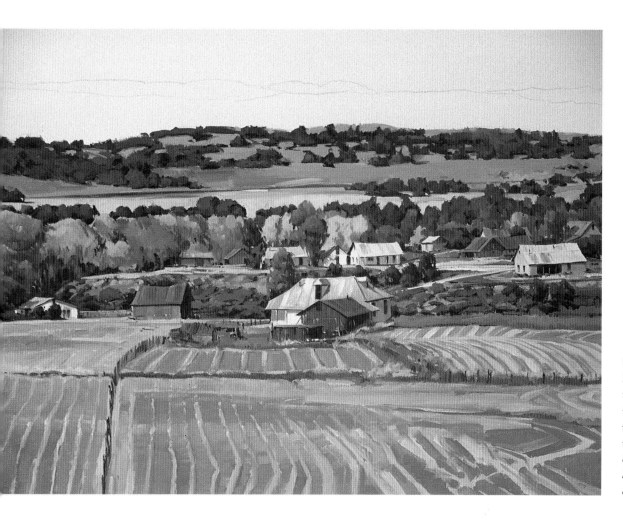

STEP 5
Hook has worked the entire painting with one brush, a no. 8 bright. He uses the corners and edges of the brush for window and tree details.

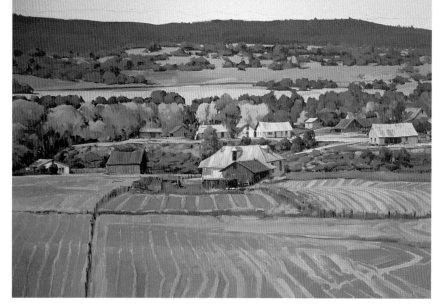

STEP 6

Hook goes on to block in darker foliage. Putting the darker areas in first helps to place the lighter colors that define the push-pull relationship of the values. Much energy is now spent on developing and defining the distant ground.

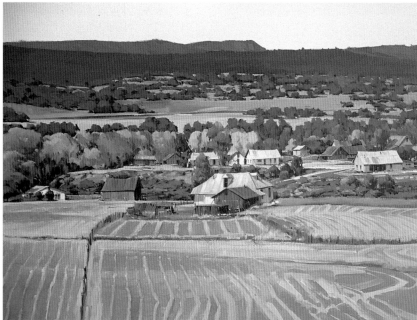

STEP 7

Because the atmosphere gives a blue cast to green, the distant mountains appear blue. Hook uses vertical strokes that the viewer's eye will perceive as trees.

DETAIL

This detail of the rural structures in the middle ground of the painting demonstrates Hook's mastery of the playful effects of light. In his use of acrylic paints, we see the dramatic contrast between the angularity of human construction and the soft shapes made by nature.

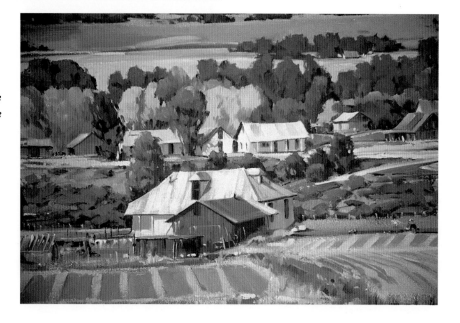

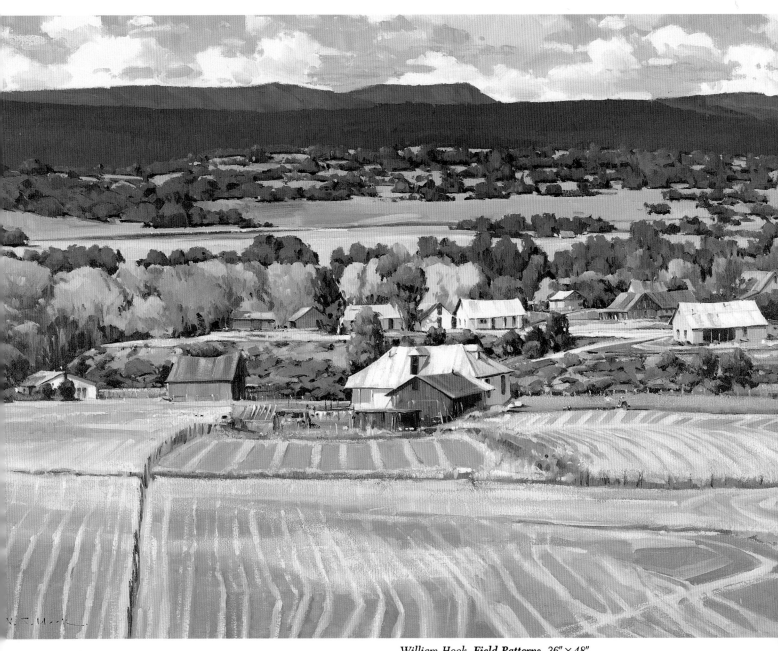

William Hook, **Field Patterns,** *36″ × 48″*

FINISH. *The pattern of dark and light values and the careful placement of colors balance and strengthen the composition, animated by confident brushstrokes.*

*H*aving seen something of what acrylic can do in the hands of some able practitioners, you may still be wondering: What is acrylic, anyway? That plastic paint, that most modern of media . . . just what is it? And if I want to paint in it, what materials do I need to be acquainted with?

Polymer colors, more recently termed *acrylics*, were developed in Germany in 1901. They consist of pigment suspended in an acrylic emulsion, minus the volatile solvents and the animal and vegetable fats (prone to decay) that are found in oil paints. I would venture to say that in acrylics, a safe and substantially more flexible, durable and correctable painting medium was born.

Materials

The Many Options

With acrylics you can use just about any method to apply virtually any thickness of paint mixed with any acrylic medium additive to an appropriate support over the course of any period of time, and end up with a picture that will remain flexible, colorfast and safe from cracking or peeling indefinitely.

Acrylic came to this country in the 1930s and was used heavily in the new plastics industry, making an appearance also in house paints. By the late forties, the medium had gained popularity with Mexican muralists, and in the fifties, it became commercially available in the United States, where it was adopted by commercial artists as well as by the abstract and pop-art scene. To some extent, the budding reputation of acrylics was nipped by the effects of gutsy but perhaps reckless experimentation on the part of its early practitioners. While acrylic can be happily mixed with a varied array of acrylic medium additives, its integrity is compromised by the commingling with other paints such as oil or vinyl, or with such inappropriate additives as alcohol. The ill-advised use of these mixtures ultimately resulted in the need for expensive restoration to pop-art works in museums and private collections, and an unfortunate casting of aspersions on the longevity of acrylic paintings.

It has taken some time and continued experimentation and development of materials and techniques to begin to bring acrylic into its own.

The Paints

When you set out to choose and use acrylic paints, some trial and error may be part of the process of finding what works best for you. But the hit-or-miss element of this process can be minimized by the information in this chapter. Written material also is available from most paint manufacturers on request or in your local art-supply store to help familiarize you with the many paints, mediums and additives that are offered.

Different Brands

Liquitex, the first manufacturer of polymer colors in this country, is the brand favored by the majority of artists in this book, myself included. There are, of course, differing opinions as to the preferability of any brand. You will find a few artists presented here, for instance, who swear by Golden or Winsor & Newton brands for their superior pigment suspension or color saturation.

I have found, however, that the "price" for the advantages of these brands is a faster drying time.

Acrylic (or polymer) paints and mediums are all basically formulated with the same acrylic emulsion. This largely accounts for the ability to paint over hardened layers of paint or varnish without fear of later cracking, chipping or peeling. The acrylic base remains the same while other additives or ingredients

Photo: Erik Redlich

BRAVING THE ELEMENTS
Acrylic colors are rated with a lightfastness of eighty years in direct ultraviolet light, and for the most part are impervious to sulphur, acids, airborne particles, rain and snow, which makes them the number-one choice among outdoor muralists.

Helen Schink, **White Rocks,** *22″ × 29″*

EXPERIMENTING WITH ALCOHOL. *Although alcohol is a solvent of the acrylic medium and is generally used for removal of mistakes, Helen Schink used it as a medium to diffuse acrylic's hard-edged effect. Will this affect the longevity of this work? Only time will tell. But one need not have a closed mind when it comes to experimentation.*

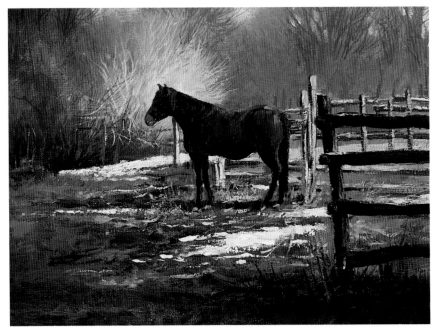

Joseph Orr, Taos Native, 12½" × 15"

BEFORE YOU PAINT. *Joseph Orr explains that many a beginner underestimates the importance of preparing the support with gesso before applying paint. Orr, who works on both canvas and Masonite, used at least three good coats of gesso, sanding between each layer for smoothness, before beginning this painting.*

Photo: Erik Redlick

ACRYLIC PRODUCTS
Each manufacturer offers a full line of mediums and colors.

Photo: Erik Redlick

SANDING
Acrylic paints (and mediums) are amenable to sanding, a technique that is useful both for creating texture and for removing excess paint or mistakes. Though acrylics are nontoxic, it is a good idea to avoid breathing the sanded dust. Here, a lightweight nose mask is helpful.

are introduced to make paint, gesso, varnishes and other additives. However, it should be mentioned that although the acrylic base is universal, each manufacturer has its own formula for making each of the various products. These differences in formula mean that one brand may or may not be compatible with another. It is probably advisable not to mix brands, or at least to test the compatibility of your chosen materials, to avoid the possibility of a curdled or nonadhesive layer of paint.

Some artists prefer to stick with a particular brand of paint for other reasons as well. Joseph Orr says, "When having to substitute other brands there is a slight difference in color, a half degree up or down the spectrum. Some brands mix smoother than others, and I have found the body, or consistency, also varies from brand to brand. This may not be noticeable or even of significance to a beginning artist, but for someone painting every day it becomes part of the many idiosyncrasies that make up a good painting experience and thus influence the finished product."

Nontoxicity

One quality of acrylic paints that has impressed every artist I've interviewed is nontoxicity. The Liquitex line, for example, consists of 132 colors, of which only five have warning labels. Liquitex has developed nontoxic replacements for these five colors, which carry the original name of the color followed by the word *hue*.

Lightfastness

Also on Liquitex labels is a lightfastness rating indicated by a number from 1 to 3. Number 1 means that the color is lightfast under museum lighting for one hundred years. Paints rated at #1 are suitable for easel painting and outdoor murals. Any rating below this should be used only by commercial artists whose work is going to be photographed for reproduction, so that longevity of the original is not an issue. For popular colors with low lightfast ratings, Liquitex has developed facsimile colors, also marked *hue*, that comply with the #1 rating.

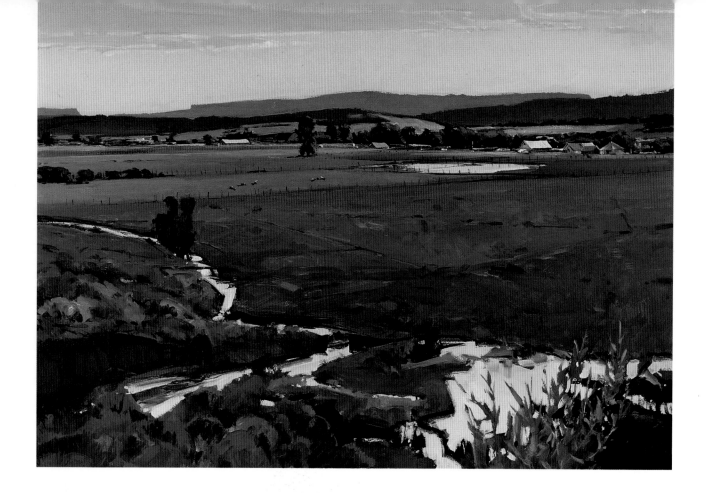

A Few Words of Caution

Regarding the use of acrylic paints, only a few cautionary words are in order. Although the acrylic medium is nontoxic, it is nevertheless a good idea to avoid breathing in dust particles if you choose to sand either a gessoed support or a paint layer. As with all painting media, good hygiene and reasonable care are important. Happily, though, there are no toxic fumes or volatile solvents used in connection with acrylics. Not only is this significant to the artist's health, but it allows more latitude with regard to when and where you can paint. If the kitchen table is your studio and you are currently painting in oil, then you might want to consider the benefits of the acrylic medium. One final caveat: You'll want to avoid getting acrylic paint on your clothing—you cannot remove it! Likewise, you should protect walls, floors or any objects from accidental splattering or spills. Although acrylic is water-soluble when wet, once it dries, it is permanent.

There is also a cautionary word to be said about *choosing* acrylic paints. Some brands put out a "student grade" of paint that is loosely termed "acrylic" on the label, but is actually pigment suspended in polyvinyl acetate (the letters *PVA* will appear somewhere on the tube). This grade of paint has the advantage of being cheaper, and you may wish to use it for sketches or studies. But its permanence is questionable, and it is never good practice to mix it with your "artist grade" acrylic paints.

William Hook, Acequia, 36″ × 48″

OPAQUE APPLICATION. *Once the support has been prepared, the versatile acrylic paints can be applied. William Hook used the paints opaquely to maximize the visual effects of his brushwork.*

A Vast Assortment

There is such a vast assortment of acrylic colors available that it can be somewhat overwhelming to the beginning artist. However, unless you're a commercial artist and need the ease of just plucking the right color out of your paintbox, you'll need only a few basic colors, a topic I will detail in chapter three.

Dore Singer, **Tea Party**, *42" × 35"*

GESSOED GROUND. *Dore Singer achieves a subtle, yet luminous color. Working on cotton canvas or untempered Masonite, she uses gesso as a ground, either smoothed with a damp sponge or heavily brushed on for underlying texture.*

Nina Favata, **Giverny Gardens**, *30" × 40"*

TRANSPARENT QUALITIES. *Nina Favata loves acrylics for their crisp transparency. She did not overwork her paint, but simply layed down a pure base color on which to overlay her transparent colors.*

Acrylic Mediums

In addition to colors, there are many painting mediums for both the artist and the craftsperson, although I will concern myself here only with the fine-art products and their uses.

Varnishes

Probably the most widely used painting mediums are acrylic gloss medium varnish and acrylic matte medium varnish. Both these mediums are good for stretching your paint volume, as well as slightly retarding the paint's drying time, increasing transparency and enhancing paint flow. Perhaps most important is the effect of these mediums on the adhesive ability of the paint. The adhesiveness of acrylic is compromised by the addition of water. Even straight from the tube, the ability of acrylic to adhere to the support is less reliable than when mixed with gloss medium varnish, matte medium varnish or one of the gel mediums. Therefore, it is a good idea always to mix one of these mediums with your paints.

A few acrylic colors are transparent, but most acrylic colors are classified as opaque. Even so, each color will vary in its degree of covering power. The necessary addition of gloss or matte medium will make the colors more transparent, and the addition of water will exaggerate the transparency. Gloss medium reflects more light within the paint layers, imparting a luminous quality. I have found that the use of matte medium flattens or deadens the color, causing a visual illusion of opaqueness. But if you wish to make your palette truly opaque, it will require the addition of white, which I will discuss in chapter three.

Either the matte or the gloss medium can be used as a finish varnish

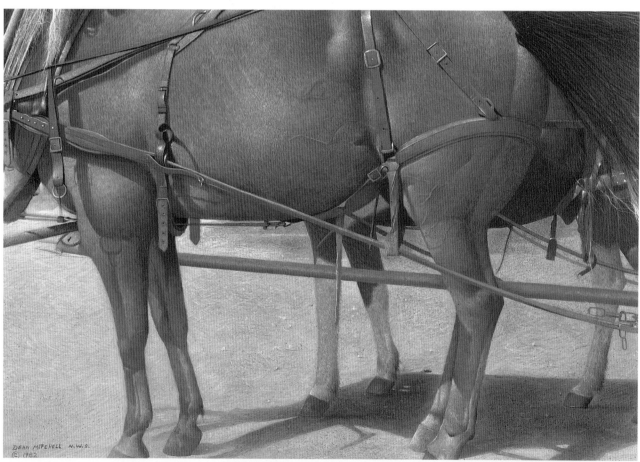

*Dean Mitchell, **Horses**, 9½" × 13½"*
In the collection of Mr. & Mrs. Baker

USING MATTE MEDIUM. *Like the paints, the acrylic mediums are adaptable to the various styles and painting processes used by different artists. Dean Mitchell often mixes watercolor and acrylic matte medium in the final stages of his painting to rework the feeling or to soften "acrylic's harshness." In Horses, Mitchell uses the same mixture also to create subtle detail, as in his depiction of the horses' flesh.*

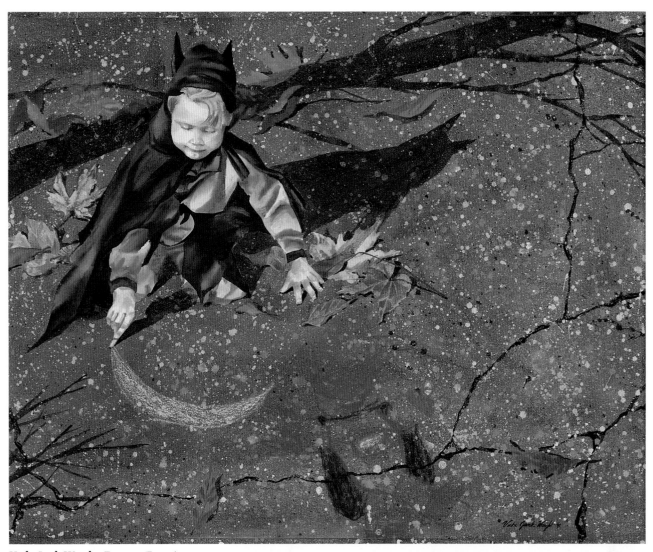

*Vicki Junk-Wright, **Batman Drawing**, 35″ × 45″*

TEXTURAL EFFECTS. *Junk-Wright created the speckles on the pavement with spattered white paint and Fleck Stone spray. This spray adds sandy texture and dimension. (Since it is nonremovable, careful masking is needed.) Fleck Stone comes with an acrylic spray topcoat that Junk-Wright has applied in several layers to seal the painting and to protect, in particular, the drawing of Batman that her six-year-old son rendered in chalk on this painting.*

*Pamela Coulter Blehert, **Sheridan Park**, 24″ × 30″*

MIXTURES FOR TEXTURE. *Coulter relies on her mediums throughout the painting process. She used water, matte medium, modeling paste and a little soap (to make surface foam and create texture).*

Vicki Junk-Wright, **Nose Level to Irises**, *6′ × 7′*

USING GEL MEDIUM. *This diptych is extended three dimensionally by a companion three-piece sculpture (36″ in height) of aluminum wire wrapped in plaster bandages, painted with acrylics, and sealed with several coats of gel medium. The frames of these pictures are painted and sealed along with the canvas. Using gel medium, Junk-Wright has collaged such elements as leaves and hair ribbons onto her paintings of frolicking children for a playful trompe l'oeil effect.*

for your painting, although I am not an advocate of this procedure. If the varnish is not applied correctly, you can end up with a cloudy and/or bubbled surface. If you do choose to use either medium as a finished varnish, be sure to read and follow the manufacturer's directions carefully.

Gels

Another useful product is acrylic gel medium, which comes in different strengths or consistencies. These mediums are labeled: *acrylic gel medium, acrylic heavy gel medium* and *acrylic geltex.* Apart from the fact that they are paint extenders and will add transparency to your colors, their main function is to beef up the working consistency of your paint body to impasto or even

sculpting potential. Again, read the label carefully before using.

Gel mediums can be useful as an additive to jar paints, which are designed primarily for easy flow for airbrush work or aquatint styles. The consistency of jar paints may not be suitable for easel painting, however, and although gel mediums can bring the paint up to its desired working consistency, the color saturation will be very much lessened compared to that of tube color.

Jack-of-all-trades, the gel mediums can also serve as vehicles for powdered pigments, sand, sawdust or any other textural element you might choose to add. Gel is also a good medium for adhesion (as is either of the varnishes) should you wish to use collage elements.

Gesso

Among the most important items in your stock of acrylic mediums is the indispensable acrylic gesso, which is not a true gesso at all, but the same acrylic-base formula with titanium white and inert particles added, making it more absorbent than the other mediums. Gesso should always be considered your first choice as a painting ground.

Other Mediums

Two mediums that I mention reluctantly are acrylic retarder and flow improver. Although they are handy tools for prolonging the drying time of your paint—making it easier to blend edges or do large, graduated-value areas—these mediums can be somewhat overused as a

"crutch"; and they are a potential hazard to your paint surface as well. If they are used more than sparingly, you can end up with a paint film that will not dry for an indefinite length of time, frustrating any efforts to continue work on the affected area.

Finish Varnish

And finally we come to finish picture varnish. As I stated earlier, I feel that the use of a *medium* varnish is not a wise choice—at least not for the beginner. However, Liquitex does produce a fine *finish* varnish called Soluvar, and you have your choice of either matte or gloss finish. It is important for any acrylic artist to understand the necessity of a finish varnish on his art work. Don't be misled by the idea that because you're painting with "plastic," your finished work is automatically protected. In fact, just the opposite is true. Because of acrylic's drying mechanism, the finished paint film is punctuated with microscopic holes that allow for evaporation. The holes also serve, unfortunately, as catchalls for moisture and dirt particles, so that under the right conditions, an unprotected painting can develop mold or show discoloration.

If matte or gloss varnish mediums have been used in your paint mixtures, this will to some extent afford a finished protection to your painting. However, because your different color mixtures may contain either or both gloss or matte medium, your painting, when dry, might appear splotchy. In that case, a good coat of either gloss or matte finish will bring your picture to a uniform appearance.

*Linda Kooluris Dobbs, **Psili Ammos**, 30″ × 40″*

VARNISHING FOR A SOFT GLOW. *Linda Kooluris Dobbs sealed her painting with a coat of finish varnish spray to give it a soft glow. It's advisable to test your finish varnish before applying it to your work to be sure it gives the look you want. Except for works done on stretched-fabric supports, it's preferable to lay the work flat (on a protected surface) and to spray from the bottom edge to the top, using even, back-and-forth strokes that extend beyond the picture on all sides. (Start spraying below the picture and don't stop until you're past it.)*

Supports and Grounds

The most important element in the longevity of your artwork is a proper marriage between the paint film and its ground and, in turn, between the ground and the support. Gesso is the ground that holds the paint film to the support. The paint sticking to the ground means nothing if the ground does not stick to the support. In acrylic painting, it is essential that the support be a material that is porous or textured to some degree. This allows many options, including canvas, linen, Masonite, wood, cardboard and paper. Etched glass, plastic and acetate can be used in commercial art, if longevity is not a concern. Any hard, shiny or impervious surface—such as polished glass, glazed ceramic, metal or

hardboards other than untempered Masonite—should certainly be avoided in the interest of a lasting piece of art.

Hardboards

It is crucial, also, for the painter in acrylics to reject as a support any material that contains waxes, oils or preservatives—all of which are present in tempered hardboards. For many decades, the hardboard Masonite has been a favorite among artists painting in oil, and *untempered* Masonite has served them well as a support. Masonite's reputation soon led to its use with other media—which are not as well suited as oils for use on this hardboard.

Hardboards vary in such qualities

*George Goebel, **Morning Shrimpers**, 25½" × 41½"*

SEALING YOUR SUPPORT. *Before George Goebel began to paint on his ¼" Masonite support, he sealed the edges to prevent them from peeling or chipping. He uses varnish or Elmer's glue.*

as color and density (that is, how compressed the inner material of the board is). In order to prepare a hardboard for use as a support, it is necessary to sand the polished surface, scrub with acetone or alcohol to neutralize the paraffin content, and prime with gesso. All these procedures using moist agents can swell and raise the inner fibers of the board to an uneven surface that would be ill-suited for painting.

Masonite (a brand-name product that can be recognized by its dark color and its embossed trademark) is by far the heaviest and most dense of the hardboards. If you are going to undertake the proper preparatory cleansing of a hardboard, Masonite gives you the best chance — although no guarantee — of avoiding unwanted particle swelling. At any rate, it is essential to use *untempered* Masonite, which lacks oil and preservatives. Apart from the front treatment, it is also necessary to varnish and brace the back of the board, which is otherwise prone to warping.

Plywood

An excellent alternative to hardboard is plywood. It is far more receptive to priming and is certainly superior as a support to natural wood, whether board or jointed.

In choosing plywood, look for a board that is single-faced (seamless) and free of any plugs. Tight-grained finish wood such as birch will give you the best results. It may be necessary, depending on the size of the support and the thickness of the wood, to use bracing on the back. In any event, both sides of the support should be primed to discourage warping.

Under no circumstances should particle board ever be considered as a support. It is inferior in strength to both Masonite and plywood and is prohibitively contaminated with glue and preservatives.

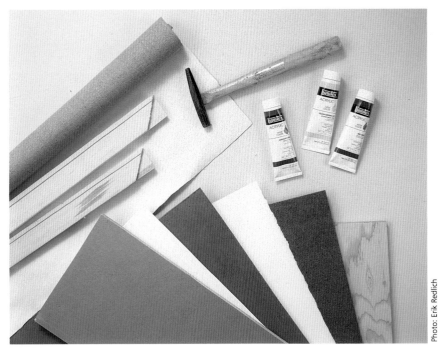

SUPPORTS
Of the many types of supports available to the artist, some are better suited than others to a particular medium. One of the most workable and stable supports for acrylics is plywood.

*George Goebel, **Sunrise at 49th Street**, 16″ × 32″*

COATING WITH GESSO. *George Goebel covered his support with six coats of gesso, and also applied a coat on the back to discourage warping. In gessoing the back, Goebel leaves a one-inch margin around the perimeter so that he can glue on parting strips to brace the panel.*

*Pamela Coulter Blehert, **Gallery, Harper's Ferry**, 30" × 24"*

EXPERIMENTAL SUPPORTS. *Pamela Coulter works on a myriad of supports ranging from Masonite to paper to museum board. If she is experimenting, she will even use cardboard.*

*Arne Lindmark, **Gloucester Tie-Up**, 22" × 30"*

TEXTURED PAPER. *Arne Lindmark used 140-lb., cold-press paper, the rough surface of which created a textural base for his painting.*

Paper

This is among the more traditional painting supports widely available in stores and catalogs. Your choices can range from inexpensive bond paper to fine Belgian linen. You will need to weigh considerations of economy, quality and durability, and how your choice will bear on the longevity of your work. Certainly for studies or practice pieces, economy can take the upper hand, while any pictures you cherish or offer for sale deserve a support that will last.

Another thing to consider is which type of support—paper or textile fabric—will be most suitable to the manner in which you're going to apply the paint. The rule of thumb here is: If you are going to use acrylic as an aquamedium (that is, watered down), the logical choice is paper; for thicker applications of paint, linen or canvas is more appropriate.

Ideally, the paper you select will be a neutral pH aquatint or print paper. A further decision to be made before painting is whether or not your completed work will be put under glass. If not, then it's a good idea to have your paper mounted to a neutral pH board before starting to paint. This will act as a deterrent to ripping or puncturing, much as glass on the front of a painting does.

You'll have a choice of paper surfaces, also. Simply put: Cold-press is rough and hot-press is smooth. Either of these textures will play a role in the appearance of your finished painting. In addition, the thickness or thinness of your paint consistency, coupled with how long and how intensively you are likely to play with your paint surface, will be important factors in determining the weight of the paper you'll need to use. To be on the safe side, you might want to try out a 140-lb watercolor paper and work up or down

from there as experience dictates.

After choosing a paper, you'll need to decide whether or not you will be priming it. An unprimed surface will lend a very flat, almost lifeless appearance to your paint. It is a good practice to stretch your paper before priming or painting to prevent bulging.

Canvas

In choosing a textile support, you'll encounter the same considerations of weight and texture as with paper. Beyond this, a variety of fabrics is available: cotton, linen, compound or synthetic, each of which has its advantages and drawbacks.

One of the most commonly used supports is canvas, which is usually cotton duck. Canvas can generally be found in three forms: canvas board, canvas roll and prestretched. Canvas board is essentially a piece of cotton glued to cardboard and primed with an "acrylic gesso." It is very inexpensive and is generally regarded as a "student-grade" support. (I must interject that I do take exception to the implicit connection between *student-grade* and *inferior*. I don't believe that students put any less of themselves into their work than do professionals, and certainly, in that respect, the student's work is no less valuable or worthy of careful treatment.)

Either the rolled or the more costly prestretched canvas can be purchased primed and unprimed. If the canvas is preprimed, be sure that it is primed with acrylic gesso, not an oil primer. If you buy unprimed canvas, you'll want to prime it with acrylic gesso before painting.

Cotton duck (canvas) would not be my first choice. Its fibers are prone to movement in response to atmospheric changes and to deterioration due to moisture. Some paintings I did in 1955 on cheap canvas boards have survived the years nicely, but some of my works from the 1960s on stretched cotton have not fared well at all. These works were all executed in oil, however, which is far more prone to damage by atmospheric elements than is acrylic. Although acrylic can stand up very well to cotton's continuing expansions and contractions, the cotton itself is prone to attack by moisture and mold. If cotton is to be stretched rather than mounted, it is helpful to iron wax onto the back of the canvas to protect it from moisture.

Mark Jacobson, **Holocaust Song,** *9″ × 12″*

PREFERENCES VARY. *Mark Jacobson relied on Fredrix Polyflax canvas, a synthetic fabric, for this painting. He prefers it over cotton or linen for its greater strength and smoothness.*

BRUSHES

When choosing brushes, try a little of everything. As you explore new techniques, methods or styles, keep experimenting with different types of brushes.

Linen

The next step up from cotton duck is linen. This fabric, like canvas, can be purchased on a roll or prestretched. Linen is stronger and more stable than canvas but also is prone to rot given the right conditions. Therefore, its back should be protected as well.

Although I live on the Connecticut shoreline with its prevailing moist conditions, linen is my support of choice. I have been successful in retarding any breakdown of the fabric by having the linen heat-sealed to a rigid support. The sealant is a clear plastic sheet called Fusion 4000, applied with heat in a vacuum press (which I prefer to standard glue mounts). It protects the back of my support from moisture as well as the acrylic paint film and varnish protects the front. As a backing or support for my linen, I use ½" MDO (medium-density overlay), available at the local lumberyard. With paintings as large as 52" I find that MDO has very little tendency to warp and needs no additional support other than a good frame. My framer does the mounting for me at about $40 a support. I supply the linen.

Compounds and Synthetics

Compound supports are composed of different natural and/or synthetic fibers. They are superior in strength to canvas or linen, but because they are composed of materials that act at variance with one another, I consider them unstable

and risky. I have the same opinion of synthetic woven supports, because of their slickness and the fact that they readily sag at 90°F.

No matter what type of support you select, it should be primed with a minimum of two to three coats of acrylic gesso.

Brushes

In selecting a brush among the astonishing assortment of shapes, sizes, fibers and "personalities," there are no hard-and-fast rules. Your enjoyment of the medium may well be enhanced by some experimentation with a variety of brushes. A good place to start is with any you might already have on hand.

If you have an idea of the finished effect you're aiming for in your painting, or if you know the paint consistency you'll be comfortable working with, you can use this as a guide in your choice of brushes. For instance, if you will be working on paper as an aquamedium, then you might want to start by using watercolor brushes. If you intend to paint impasto, you'll probably find that brushes used for oil paint will do the trick. This is only a starting point; it is not to say that these brushes cannot cross over the line or that there are not other options. I use a palette knife, stencil brush and my fingers almost exclusively in my work. And at times nothing can beat a good two-inch house-painter's brush.

Among the brushes available, you will find flats, rounds, brights, filberts and fans of different sizes, lengths and fibers. Fortunately, high-quality brushes appropriate for the acrylic medium are reasonably priced, so you needn't run out and buy $.15 squirrel brushes or $60 sables. I'd advise against taking the cheapest route, which will probably lead to picking hairs out of your paintings and feeling that you wasted your money. On the other hand, bear in mind that acrylic paint can be extremely destructive to brushes, especially if they are used in a manner not suited to their particular design, or worse, if they are not kept moist when in use and submerged in water when not.

The length and size of the brush head will determine the amount and consistency of paint you can successfully manipulate. In addition, the fiber makeup of the brush affects the handling of the paint. There are two basic types of fiber: natural (made of coarse or fine animal hair) and synthetic (generally nylon).

Natural Fibers

Many of the contributors to this book successfully negotiate their work with fine sable brushes. Because of their soft and fluid characteristics, sables are excellent for passages composed of thin washes, fine lines or crosshatching. They are not suitable for more vigorous applications, such as scrubbing. The effect they would produce might very well

be desirable, but the lifespan of the brush would certainly be in question. The only real drawback I see with natural fiber brushes, apart from their cost, is that the acrylic medium is extremely hard on them.

Natural fibers, as opposed to synthetics, seem to have less "let go" power. That is, the brush will have a tendency to bend at a 90-degree angle at the ferrule before it will release the paint. This causes hairs to weaken and eventually break off, especially if the paint consistency is heavier than the brush was designed to handle. Even with oil bristle brushes, the natural fiber tends to accumulate paint at the ferrule and ultimately cause damage to the bristles. This is not to say that you should not use natural hair brushes, but it does suggest that you need to give them a little more care in the painting process and in clean-up.

Synthetics

Synthetic brushes, on the other hand, seem to have more resiliency. I have found that they have a little more tension, which prevents the hairs from bending back against the ferrule, and that the paint is a little more energetic at leaving the brush and going onto the support.

Also, in clean-up I find a marked difference between the two types of fiber. With the natural fibers, the paint is more stubborn in vacating and requires the use of soap. This, in turn, requires extra time to thoroughly rinse the brush to be sure it doesn't retain any soap residue, which would act as a repellent to my paint the next time I work. By contrast, my nylon brushes are simply removed from their immersion tray at the end of my day, rinsed and put away.

*Laura Anderson, **Pear Trilogy**, 24″ × 40″*

USING FAN BRUSHES. *Fan brushes enabled Laura Anderson to achieve a stroke-free surface for realism with a dreamlike quality.*

*Carol Decker, **Countryman**, 24″ × 18″*

A PREFERENCE FOR NATURAL FIBERS. *Among a variety of other tools, Decker used assorted natural fiber (sable) large flats and rounds to cover the surface and fill in shapes. Later, she used smaller rounds and liners for details. Decker advises: "Always buy the best you can afford. Better tools will work better and last longer."*

*Robert Bissett, **Rose #3**, 30″ × 40″*

USING SYNTHETIC BRUSHES. *Robert Bissett used small-to-medium synthetic (nylon) brushes, both bristle and soft-pointed types in this painting. He uses only one natural-bristle trim brush (from the lumberyard) for washes.*

Care of Brushes

While working, always have a flat tray of water near your palette so that brushes may be soaking in a prone position to preserve their shape. Also, it's helpful to periodically dip your brush in water, then lightly wipe it to remove excessive water that could change the consistency of your palette colors; but leave enough moisture in the brush that the paint will not have the opportunity to dry and collect on the bristles or in the ferrule. A second benefit to having your brushes immersed in water is that you will always have a clean brush to use.

It's likely that once you have found the type of brush that works best for your painting method and style, you may also find that only a few brushes will do the whole job. Again, I recommend that you go slowly in making your acquisition of equipment until you have developed an idea of what works best for you and your working methods. And by all means, don't overlook some of the best tools you already have in your possession — your fingers and hands!

Earl Grenville Killeen, **Interstices,** *40″ × 30″*

WORKING WITHOUT A BRUSH. *This painting was done with a minimum of tools. I mixed my colors and brought them from the palette to the support with a stencil brush. From there, they were handled with a palette knife, except for the last two or three coats of paint, which I manipulated almost entirely with the palm of my hand and my fingers.*

Palettes and Containers

Here you can relax, for there are no difficult choices to ponder in selecting a paint palette. Probably the one important thing to remember when mixing your paint on the palette is to mix a more-than-adequate amount. Because acrylics dry slightly darker on the support than they appear on the palette, it is difficult to mix a color to match one that has been used up. Hence, it is always better to have leftover paint than to find yourself running short.

For this reason, having a single flat or small-welled palette may not be enough. You might want to consider having a large containment system, as well as a mixing palette.

Containment systems, as well as palettes, can be any shape or form, found objects as well as store-bought. Many artists use glass jars, margarine tubs, film canisters or other plastic containers that repel the paint and make for easy clean-up.

Among the items sold in art-supply stores, plastic watercolor palettes look attractive but seem poorly suited to our purpose. They are overpriced, do not clean up easily and have paint wells too small to be serviceable. On the other hand, three-inch plastic cups that cost about fifty cents apiece are unbreakable, readily hold an ample amount of paint and give up dried paint film with very little struggle.

Arranging the cups on a tray prevents tipping and facilitates switching setups or storing. When I finish working for the day, I simply slip my trays of cups as well as my palette into plastic garbage bags. In this manner, I have been able to store paints for several months with very little attention or addition of water.

PALETTES

Almost no holds are barred in choosing receptacles for your paints. Experimentation will help you find what works best. Virtually any plastic or glass surface or container will do, so rummage around your house before rushing to the art-supply store.

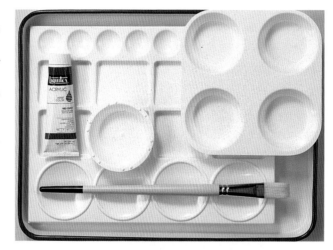

CLEAN-UP

White plastic paint cups readily yield dried acrylic paint, making clean-up a snap. (By the way, the dried paint can be cut up and collaged onto a painting.)

Care of Palettes

If you will be storing paints that have been mixed with water, it is best to use distilled water and to cover the palette securely. Tap water, as well as humidity, can contribute to the growth of mold on the paints.

Uncovered paint or paint in prolonged storage can develop a skin on the surface. The skin can easily be removed, but care should be taken that no hardened particles are left in the paint that might later end up on the support and potentially spoil a passage in your painting.

If the paint in your containers begins to stiffen as a result of drying, you may find it necessary to add water. It is important also to add more medium, to maintain the adhesive power of the paint. Of course, this process can affect the hue's intensity, and you might find it necessary to add more color as well.

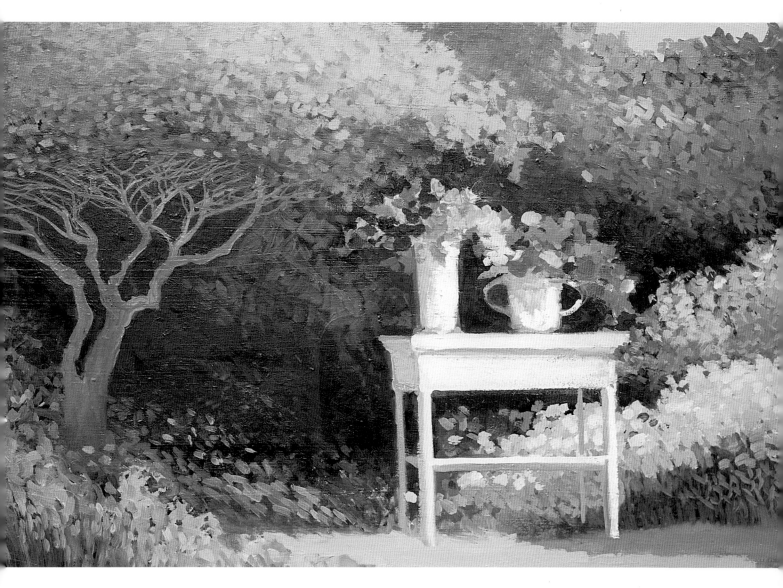

Types of Palettes

For mixing or containing smaller amounts of color, you'll need a palette. The most popular and sensible palette is a wet palette. This can be constructed by taking a shallow tray, such as a porcelain butcher's tray, and lining the bottom with several sheets of paper towel. Moisten the toweling with water and cover it with a sheet of good-quality tracing paper. The tracing paper will be your mixing surface.

Properly stored, your paint will stay moist and workable for weeks. It is important to add water periodically to your toweling. However, adding too much water will moisten

the tracing paper to a point where it will rip or shred under the pressure of your brush or knife. It might take a little time and experience to get the right degree of moisture.

Another choice is a sheet of glass. The glass is easy to clean by simply razor-blading the dry paint off. The only drawback to this system is that your paint is exposed to air and will tend to dry up quickly. Many artists who use glass palettes retard the drying time by the use of a spray bottle containing water. However, overzealous spraying will do more damage than good to the paint, so it's best to proceed sparingly.

*Anda Barbera, **The Secret Garden**, 18″×36″*

A GLASS PALETTE. *Anda Barbera uses a sheet of glass as a palette. It rests in a flat tray. This setup allows Barbera the convenience of being able to scrape off drying paint quickly and easily. However, the paint dries much faster than on a wet palette, and may require occasional misting with water. Care must be taken, though, not to overmoisten the colors.*

William Hook, **Rear Window,** *40″ × 36″*

olor is probably the most exciting ingredient in painting; and the acrylic medium offers a wonderful array of color choices, which begs the questions: How does the acrylic artist know where to begin in selecting her palette colors? And what are the "proper" methods of applying the colors to best advantage?

Opinions on color theory and how to use it are probably as numerous as the multitude of hues available in acrylic paints. But a lengthy or highly technical discussion of the subject is not necessary here. (If you wish to pursue the theory of color more deeply than we shall in this chapter, you may find a workshop on the topic helpful. Many books are also available, such as *Energize Your Paintings With Color* by Lewis B. Lehrman, *Blue and Yellow Don't Make Green* by Michael Wilcox, *Exploring Color* by Nita Leland and *Interaction of Color* by Munsell and Alders.) Here, various artists will demonstrate and explain the workings of acrylic colors in their paintings. First, though, let's take a look at a few basic terms and concepts concerning color.

In the vast assortment of acrylic paints, you will find all the pigments found in oil and watercolor, and in addition, many wonderful synthetic colors not found in other media. While it is certainly an asset to have such a variety of colors to choose from, when it comes to putting them into a painting, *more is not necessarily better*. In order to more easily maintain color harmony in your painting—or, we might say, to make sure your colors will "hang together"—it might be best to start out with a limited palette.

Many artists prefer to stick with a limited palette. Others, having at some point filled their paintboxes with a kaleidoscope of hues, later decide to cut back to the basic few that work best for them; still others, of course, work well with a wider range. Really the best way to develop your own color sense and the palette you'll feel comfortable with is through a little practice and a little patience.

Color

Method in the Mixing

Geri Keary, September Lilies at Lagoon Creek, 19″ × 29″

USING A LIMITED PALETTE. *Keary's use of a limited palette is a good example of getting a lot out of a little. Using only a few colors, she gets a balanced effect from her warm cools and cool warms.*

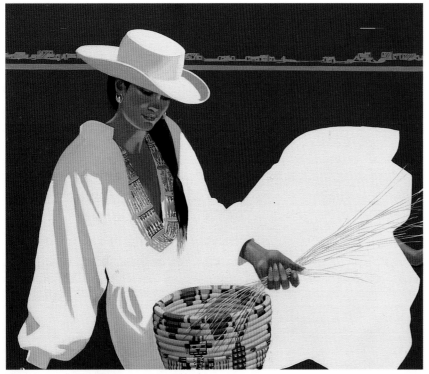

*Dore Singer, **Out West**, 30″ × 40″*

EMPHASIZING DESIGN OVER COLOR. *Although Dore Singer is an expert with a full range of colors, she is equally successful here using a nearly monochromatic palette, relying solely on the strength of her design elements.*

The Color Wheel

Another device that some artists find useful is a color wheel or color chart. Most paint companies offer color charts depicting the mixing and blending of their colors.

It might be more useful, and of greater educational value, to construct your own chart. A number of different approaches will work, some very informal. A chart can show gradations of value or opacity for each color, for instance, or can demonstrate the results of color mixing.

Make a Chart

To make a chart that will serve as a guide to glazing, start with a grid. Beginning one square from the upper-left corner, label each square in the top row across and again in the left row down with the name of one of your colors. Then, starting with the first square on the left, brush in the designated color all across the row. Do the same for each of the colors named on the left until the grid is filled with horizontal stripes of color. Now repeat the same procedure in each vertical row, glazing the colors named along the top down over the lengthwise stripes.

You'll notice that the original colors laid out on the horizontal and vertical edges will also appear on the diagonal bisecting the grid, though somewhat more intense because of the overlapping layers of paint. The colors on the bottom layer in the squares to the right of the diagonal will be on the top layer in the squares to the left of the diagonal, so that every glazing possibility will be shown. You'll see that red over yellow, for instance, is not the same as yellow over red.

In making such a chart, you will learn something about how your colors work and interact with each other. The completed chart can be used as a reference when painting.

Color Vocabulary

It will be useful to briefly clarify some of the terms used in connection with color.

Hue

Hue refers to the color's "proper name," such as red, blue-green or yellow ochre. The *primary* hues are red, blue and yellow. Theoretically, by mixing two primaries, you will get a *secondary* color—purple, green or orange. *Tertiary* colors, such as red-orange or yellow-green, are made by mixing a primary with a secondary. A basic color wheel places the colors in sequence around a circle (as red, red-orange, orange, yellow-orange, yellow, etc.). A color wheel is helpful in finding *complementary* colors, which are opposite each other on the wheel.

Value

Value denotes the relative lightness or darkness of a color. Every color fits somewhere on a graduated scale of values. However, values are probably easier to see when the hue is absent, as in a black-and-white photograph, where the values appear in every gradation of gray from white to black. To better judge the values in your subject or on your painting, squint your eyes.

Saturation

Saturation of a color is its relative brightness or intensity. At one end of the spectrum a color is "intense" or "highly saturated"; at the other end it is "subdued" or "muted."

Temperature

Temperature applies to colors as they appear to be relatively "warm" or "cool." Warm colors tend to advance from the picture plane, and cool colors seem to recede. Color temperature can also affect the mood of a painting.

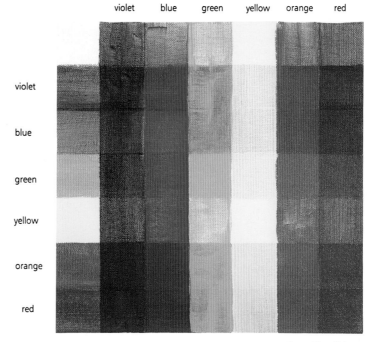

Photo: Erik Redlich

COLOR CHART

This easily made color chart can serve as a guide to glazing. You can include selected colors, or all the paints in your palette.

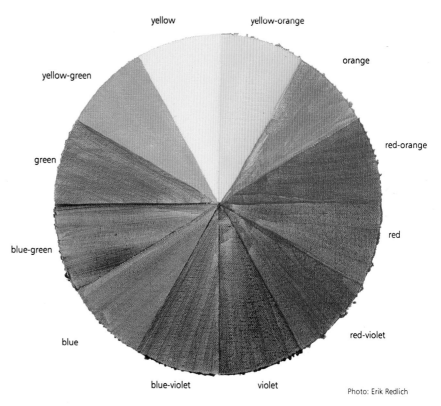

Photo: Erik Redlich

COLOR WHEEL

This color wheel was made with one coat of acrylic paint mixed with gloss medium. As you can see, successive applications are needed to build opacity and intensity. Complementary colors, like red-orange and blue-green, can be found opposite each other on the wheel.

Other Color Properties

The value, saturation and temperature of your colors can all be used to help create an illusion of space, three dimensionality or aerial perspective.

The addition of titanium white will make a color less *transparent* (more *opaque*). However, it will also make the color lighter in value. To restore the value, a compatible dark pigment (not black, which alters the hue) can be added, or used as an underglaze. Liquitex makes it easy to find compatible colors by coding each tube with letters that indicate placement on the color wheel. For example, to a purplish blue (coded *BP*) you might add another purplish blue, rather than a greenish blue (*BG*).

Colors can be mixed on the palette and then applied. Alternatively, they can be "mixed" on the support by glazing one color over another (dried) color, or by placing dots or areas of colors next to one another so that to the viewer's eye they appear to mix (optical mixing). The appearance and effect of a color will be affected by the various properties of the colors it is placed next to. For example, yellow will appear cooler next to red and warmer next to blue.

Earl Grenville Killeen, **Pearanoia,** *42" × 30"*

CONTRASTING COLOR TEMPERATURES. *In* Pearanoia, *I use contrasting color temperatures to create energy and a sense of impending movement. If it were not for the deep shadows "holding" the warm red pears down to the cool blue table, they would almost appear to shoot out into space. The warm colors of the foremost pear have been "cooled down" to emphasize its isolation, its ejection from the game that pears play when we're not looking.*

Linda Kooluris Dobbs, **The Pink Rocking Chair,** *30" × 24"*

OPTICAL BLENDING. *"Optical blending" of colors can be done by glazing, by placing multi-colored pointillistic dots, or—as Kooluris Dobbs does here—by juxtaposing flat patches of color.*

Painting With a Limited Palette

Brad Faegre is an artist who is well-versed in color theory and at the same time keeps an open mind and eye to new experiences using color. As a result, his use of acrylic colors has evolved from an extremely limited palette to a vibrant and more varied one, though still restricted to a handful of deliberately chosen colors. He explains, "Many years ago, I became so impressed with the paintings and teachings of Emil Gruppe that I adopted his austere palette for my own. The palette consists of only six colors: a warm and a cool hue from each of the primaries—red, yellow and blue—plus white. The cool colors are deep magenta, Hansa yellow and ultramarine blue; the warm colors are cadmium red light, cadmium yellow light and phthalocyanine blue; the white is titanium white.

Warm or Cool Light?

Gruppe's theory teaches that the colors of all objects found in nature are determined by the light source that illuminates them. Consider a simple object like an apple, placed outdoors, as an example. The part of the apple receiving direct sunlight will appear warm in hue. On the opposite side of the apple, out of direct contact with the sun's rays, the hue will appear cool, reflecting the color of the blue sky. From this simplified example, you can visualize why a cool and warm hue of each primary color are necessary on the artist's palette.

Keep It Simple

After working for a year with this limited palette, Faegre started to add premixed tube colors such as yellow oxide, raw umber and burnt

*Brad Faegre, **A Path Through the Oaks**, 12″ × 18″*

ACHIEVING RICH COLOR. *With his skillful use of a limited palette, Faegre shows there's virtually no limit to the richness and apparent variety of color Brad Faegre achieves.*

sienna, and secondary colors like cadmium orange, dioxazine purple and Hooker's green. Although the convenience of adding premixed colors has enlarged his palette greatly, Faegre still subscribes to the idea that too many colors can present too many options, "thus promoting both muddied thinking and muddied color combinations."

Faegre is very attuned to color language, having a keen understanding of how warm and cool colors interact and how they convey an impression to the human eye and mind. Yet he still paints to some extent on an instinctive level. Mixing a color and laying it on the support, he finds, will dictate the next color to be applied.

Keep Neutrals Lively

As a landscape painter, Faegre is constantly challenged by the problems of reflected light and aerial perspective, the fact that colors in distant objects appear muted or "grayed down." How is this grayness best conveyed in paint? Although all brands of acrylic paint offer warm, cool and neutral grays in many different values, Faegre prefers to use complementary colors for toning down hues. Neutral grays, he feels, just deaden the colors.

Examine Your Subject Carefully

Faegre believes that one must examine the color one is looking at, instead of just reacting to it. How many of us are guilty of the idea that grass has to be *green*? Green as a paint color, though, can be harsh and "unnatural," and Faegre comments, "Thalo green is death." Seeing "the color *in* the color," he never uses paint straight out of the tube. When he does use thalo, he will add magenta, purple, burnt umber and cobalt blue to tone it down. Such mixing also has the effect of enriching the straight color.

*Brad Faegre, **Summer Love**, 12″ × 18″*

LEARN FROM THE MASTERS. *Brad Faegre's sometimes "simplistic" use of shape, value, color and light comes from many years of observing the masters' paintings. He recommends that all artists look critically at works of art and "incorporate and synthesize what you see into what you make."*

*Brad Faegre, **Claremont Oaks**, 10″ × 11″*

RENDERING DISTANCE. *This painting demonstrates a knowledgeable rendering of distance by means of color and value. Painters generally convince us that objects are distant by toning them down with complements or grays, subduing the hue. But some, in addition, mistakenly lighten the value of background objects. In Faegre's paintings, we see that, with consistent lighting, objects viewed*

The Language of Color

PRELIMINARY DRAWING

Brad Faegre was intrigued by the fixed stare of this cat, which was so intent upon an object out of the artist's line of vision that it did not notice Faegre as he quickly sketched it. In his drawing (ink on paper), a butterfly stands in for the unseen "prey."

PASTEL STUDY

Faegre will not proceed until he's satisfied with his drawing. He follows up his drawing with this pastel study on black gesso. As a teacher, he comments: "The most common mistake I see is poor planning. Anxious to start, people boldly apply paint without even the simplest thumbnail sketch as a guide. This is a recipe for failure."

Faegre begins by premixing colors on the palette that will be applied to his support as the initial paint layers. But as the painting progresses, he will start painting wet-into-wet with little thought of homogenizing the various colors, creating a peekaboo effect that can be perceived as "optical mixing" of opposing energies. This gives Faegre's work an almost overwhelming aura of substance and force.

Faegre, like many other artists, finds the brilliant and highly saturated acrylic tube colors a bit too intense, sometimes even garish. Therefore, he will spend a great deal of time premixing his darks and lights on the palette. This allows him the facility of striking it right with the first passage of the brush, a feat he alludes to as a "happy accident." In the end, his painting surface may be composed of many layers set off to completion by a single "happy" one.

For the beginner in acrylics, Faegre advises starting out with a limited palette and expanding as you become more comfortable. "Don't be timid with your color. Too much color [as distinct from too *many* colors] is better than too little. Don't be afraid to experiment, and enjoy yourself." He also highly recommends that students visit art shows and museums as often as possible and just drink in what has been done—and what can be done—with color.

STEP 1

Beginning on a support coated with black gesso, Faegre makes a sketch using the pastel study as a guide.

Still referring to his pastel study, Faegre now begins applying a few colors in the middle-value range, to start defining shapes.

STEP 3
Confident that all the most important shapes are now in play, Faegre works over the entire surface of the painting to prevent an uneven finish in the end.

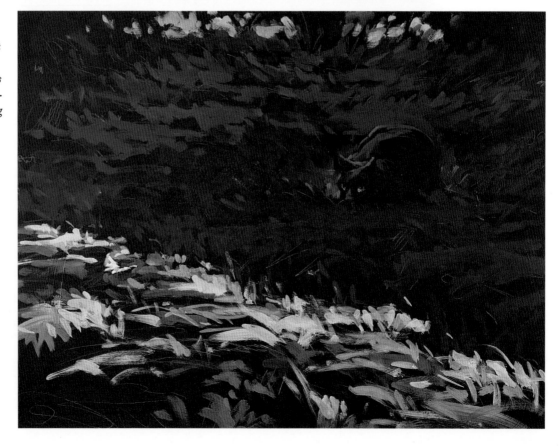

DETAIL
After all modifications are made to keep the viewer's eye moving to the cat, Faegre can go on to the finishing touches.

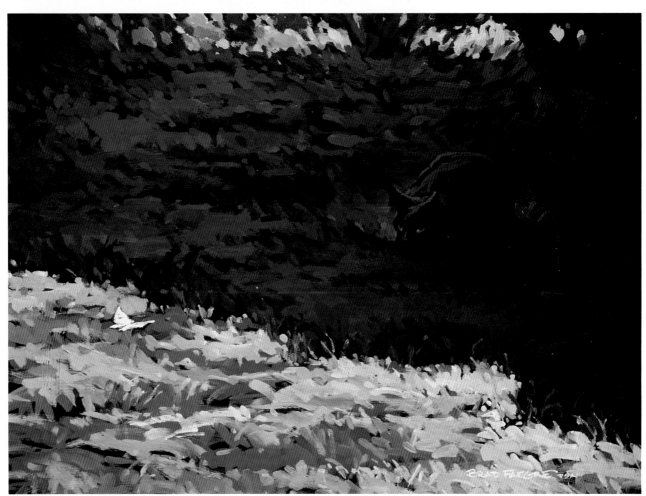

Brad Faegre, **The Stare,** *24″ × 30″*

FINISH. *Faegre is careful to provide enough variety in the colors, the values, and the shape and direction of the brushstrokes to make the painting interesting and to convey the drama of the scene. He explains that "surrounding the cat's body in warmer tones than the background makes it stand out just enough to be seen, and transmit a signal of danger. The cat's eyes and body direct our gaze out of the shadows, into the light and to the butterfly."*

Toning Down

Laura Anderson makes no bones about acrylic colors being too intense for her. As a painter in oils, she had no trouble with the chroma (hue + saturation) of the oil pigments. But with acrylics she took a different tack, setting out to diminish the intensity of her colors by toning them down. Anderson's palette many be very similar to that of many an acrylic painter—except for her use of unbleached titanium and parchment as replacements for white, and her use of neutral grays #3, #6 and #7. Her partiality to such "toners" might lead us to suspect that Anderson is engaged in painting a series entitled "Two Ships Passing in the Fog," but a look at her work convinces us that this is not the case at all.

Anderson is a deliberate and patient artisan, who also believes in constant experimentation. She favors opaque colors without medium additives to communicate her sensibilities with striking effects. Her palette is particularly adept at conveying mood. She uses color and a full range of values—without the expected "glare" effect—to achieve a tranquil mood. Her pictures seem to evoke memories—of places we have never been to! The subtle mood of muted colors takes on a dreamlike quality, borne out by the harmony of the compositional elements.

Laura Anderson, **Red Chairs, The Wait,** 28″ × 40″

CREATING MOOD WITH CONTRAST.
Seeing the dramatic possibilities in strong contrasts, Anderson says of this painting: "I wanted to contrast bright red chairs against this bland background, to balance the dark green lattice boards over the house foundation. This contrast in color against a gray sky and water (made luminous by scrubbing) helps to accentuate the tension and the feelings of solitude I want to convey within the context of the landscape."

Laura Anderson, **Spring House, August,** *32″ × 44″*

PAINTING A LUMINOUS SKY. *For the sky, Anderson says, "I mixed several different shades in separate mixing cups. Layer upon layer, scrubbing light blue into an already-applied darker blue shade and sometimes reversing this process (that is, dark into light areas) I continue until I feel I have achieved a uniform and luminous color graduation."*

Laura Anderson, **Six Blue Chairs,**
20″ × 30″

A FASCINATION FOR LIGHT. *With a keen eye for the subtle workings of color, Anderson was drawn to this subject by a "fascination with the way light illuminates a blue canvas chair." She responds to the challenge of depicting the "atmospheric" background colors in relation to the light reflections on the chairs and table.*

Laura Anderson, **Pears and Stems,**
20″ × 30″

A SOLID COMPOSITION. *Laura Anderson's rendering of light and reflected light shows astute observation of color. Like all her work, this picture is compositionally strong, and the mood is conveyed mostly through the use of color.*

A Color Celebration

Robert Bissett's celebration of color reflects the serious study and hard work he brings to bear as a painter. Bissett's first recommendation for mixing colors is to mix ample quantities. Experience has shown him the difficulty of matching a color on the palette to one that has dried on the painting, for acrylics darken as they dry. He cautions, also, about the dulling and cooling effects of white: "When lightening a color with white, add something else as well— like yellow, cadmium red light or cerulean blue—to maintain the chroma [saturation]. As a last resort, chroma can be restored by glazing."

Bissett demonstrates in his paintings his conviction that "color identity must be evident in all mixtures. That means we paint with semineutrals, not with colors completely neutralized by their complements. Even when the subject requires a gray, it should read warm or cool, not dead neutral."

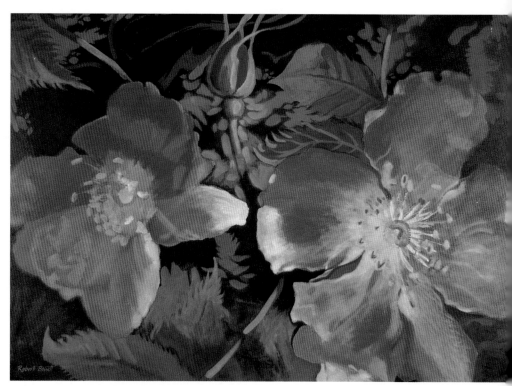

*Robert Bissett, **Rose #2**, 30″ × 40″*

VALUE, COLOR AND SHAPE. *Robert Bissett's seemingly simplistic division of planes of color gives his works viability apart from the identity of the pictorial matter. As Bissett explains: "Value, color and shape are part of the language of painting. At some point in the painting process, these elements take on meaning independent of the literal appearance being portrayed. This is the origin of abstract art."*

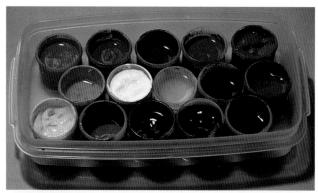

MAIN PALETTE

Robert Bissett models his primary palette arrangement after a color wheel in one-ounce cups set in a plastic tray with about a half inch of water in the bottom. His colors, arranged in a clockwise spiral starting at the upper-left corner, are: Indo orange red, cadmium red deep, alizaron crimson, Boucour violet, prism violet, blue-purple (mixed from cobalt blue and dioxazine purple), thalo blue, manganese blue, thalo green, permanent green light, cadmium lemon yellow, cadmium orange, plus titanium white, matte medium and ivory black. Removing the one plastic cover makes fifteen colors in large quantity immediately ready for use.

SECONDARY PALETTE

Adding this set of "additional colors" to Bissett's primary palette still totals only half of the sixty colors he uses. Here we see, starting at the left (top): raw sienna, burnt sienna, dioxazine purple, quinacridone purple, cobalt blue; (middle): Indian red, cadmium red light, cerulean blue, gesso; (bottom): yellow oxide, raw umber, burnt umber, viridian, Prussian blue.

The Importance of Rich Color and Value

Although Bissett works with about sixty colors in his palette and has made three different color charts for his own use, covering both transparent and opaque mixtures, he is far from a formula painter. He's not afraid to try something; if it doesn't work, he simply changes it. Bissett's handling of color translates into pictures of striking intensity, but the artist believes that more important than color itself is value: "Seventy to eighty percent of your focus should be on nailing the values and their relationships to one another."

How does Bissett use value to breathe life into his acrylic paints, keeping them from looking flat or dead? "When building up values," he says, "I generally go darker than intended, then correct by scrubbing on a semiopaque. This results in much richer character than just a flat coat of paint. The darkest darks and the lightest lights are reserved for small touches of accents and highlights, respectively."

STEP 1

Combining imagination with memory, Bissett starts by thickly applying gesso to his panel with a knife. Using the knife and a pointed chopstick, he completes a "drawing" consisting only of texture. Making initial passes of manganese blue wash for the sky, ultramarine blue for the mountains, thalo blue for the tarp, raw sienna for the hay, viridian and ivory black for the trees, and viridian for the field, Bissett has worked the entire surface of the picture plane. Now he must wrestle in the arena where "good drawings don't necessarily make good paintings."

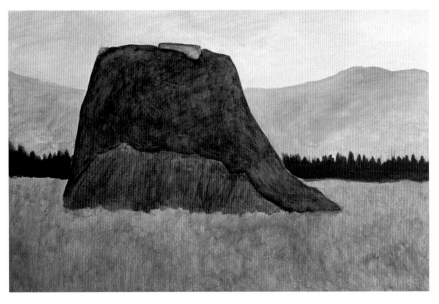

STEP 2

The second pass begins with yellow oxide and white for the sky. The mountains, fields and hay also receive washes containing yellow oxide; cadmium red light, along with various greens, is added to the trees. Bissett finds that "the picture is now unified by an overall yellow cast. The beginning of a color scheme and the relative values are showing some promise."

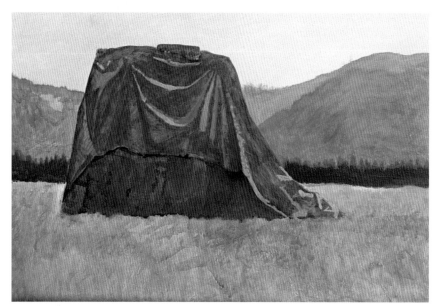

STEP 3

Washing or scrubbing over his colors for the third time, Bissett changes the shape of the mountains, suggesting trees on the ridges. He corrects what seems a "too neutral" color by washing thalo green over the mountains, and over the field as well. On the tarp, corrections are made with gesso, and highlights and shadows roughed in with thalo-green-plus-white and thalo blue, respectively; shadows on the hay are darkened with burnt umber.

STEP 4

Bissett begins the fourth pass with another thalo green wash of the field. He finds the mountains too intense and compensates by scrubbing over them with a translucent mixture of prism violet and white, followed by a wash of thalo blue. Individual trees are suggested with thalo green and cadmium red light for the darks, and permanent green light, cadmium red light and white for the lighter values. The field and hay receive washes of raw sienna and cadmium orange. Shadows are added to the hay with burnt umber, and sunlit spots, with pure gesso.

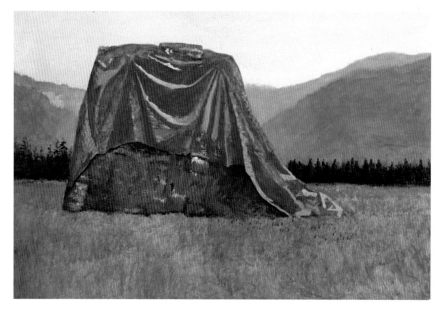

STEP 5

Further washes develop the depth and modeling of the elements. To suggest alfalfa, Bissett adds little spots of permanent green light and white near the haystack. The mountains, he decides, are too patchy and distracting. He mixes thalo blue, thalo green, cadmium red light and white to make a blue-green gray, which he scrubs over the mountains in a few different values made by varying the amount of white.

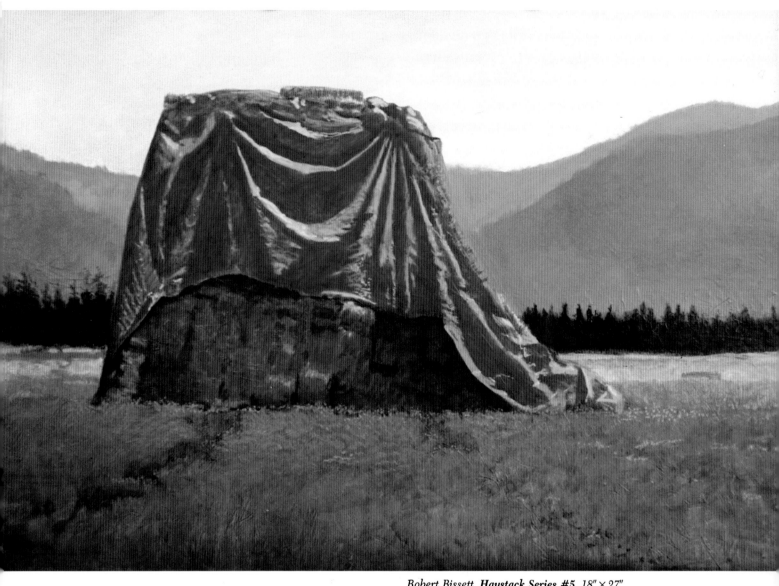

*Robert Bissett, **Haystack Series #5**, 18" × 27"*

FINISH. *As the mountains still seem too dark, Bissett decides to try darkening the hay and the tarp. He deepens the shadows on the tarp with quinacridone purple and on the hay with a burnt sienna-thalo green mixture followed by burnt umber. He reinforces the visual "path" leading through the field to the haystack with thalo green. Noticing a radial motif emerging, he strengthens it by adding another "path" through the field. Last, final adjustments, highlights and accents are added.*

Capturing the Greens of Nature

Rendering the greens of nature is one of the most difficult challenges to the colorist. Otherwise-lovely landscape paintings can die from the ill use of green. Anda Barbera's charming depictions, ordered and calm, are especially intriguing because of her masterful use of the color green.

Like her paintings, Barbera is energetic in her approach. "Take risks and mix what you think you shouldn't mix!" she advises with enthusiasm. "I tell my students to study colors in nature—in everyday life. Just look around—there is so much to observe."

Although Barbera believes that students should have at their disposal a full range of colors, she tempers this by telling her students they should experiment with using only a few of the most basic colors.

Look Slowly, Paint Quickly

While Barbera advises us to paint quickly, she expresses the importance of *looking* slowly. "Look at a red barn, for example. Notice how the same red changes in the bright sunlight and in the shade." Barbera does most of her color mixing on the palette; she applies the paint very directly, doing a small amount of mixing on the canvas and very little glazing. What little glazing she does is most often over a predarkened area, usually Winsor & Newton olive green. Barbera uses olive green as the base color for the start of all her greenery. To this, she will add not only other greens but also colors like cadmium orange and ochre. Like Faegre, she advises students to stay away from thalo green. And for Barbera, black is out: "I don't even own a tube."

Anda Barbera, **Going Back in Time,** *40" × 36"*

PAINTING FOLIAGE. *Anda Barbera's successful use of the color green owes a lot to her patient and astute observation of colors in nature. To paint the foliage, for example, she did not simply reach for a tube of green paint, but enriches her greens with other hues that she saw in the color of a leaf or shrub.*

*Anda Barbera, **Indian Summer**, 20″ × 30″*

A DIRECT METHOD. *Anda Barbera does very little glazing. Her direct manner of painting relies on colors mixed on the palette as well as optical mixing on her support, which she usually works light over dark.*

*Anda Barbera, **Autumn Begins**, 20″ × 30″*

Dean Mitchell, **Dancer in Blue,** *33¾″ × 27⅝″*

*N*ow that you've been properly introduced to acrylics—to the paints, mediums and other tools of the trade, to the colors and their properties, and to a variety of artists working in the medium—you're ready to take your paints from the palette to a chosen support. It's time to roll up your sleeves and plunge your hands into some techniques.

Technique

Jumping Into the Thick and Thin of It

As promised in the introduction, the versatility of acrylics is borne out in the range of applicable techniques, any one of which can be used effectively alone or in combination with others. Whether you like to paint wet or dry, thick or thin, with a brush, a knife or your fingers, methodically or spontaneously, finely or broadly, you'll find the acrylic medium responsive. If you want your finished picture to appear pristine and translucent, richly layered, densely opaque, smooth, textured, sculpted, collaged or combined with other media—acrylics can do it. And if you approach your goal with an open mind—even a tolerance for passages you had not intended—chances are you will learn very quickly the joy of painting in acrylic.

The joy of painting in acrylic—to me this is no mere slogan or cliché. Having worked for decades in several different media, it was not until I became acquainted with acrylics that my artistic temperament took an upturn and I could actually refer to my daily activities in the studio as "having a good time." Of course, there are still moments of frustration, and the sign on my studio door still warns, "Beware of Flying Brushes," but for the first time, *fun* is in my painting vocabulary. A major reason for this is what I call acrylic's "open-door policy": once you learn one thing about this medium, a door opens and you realize that the learning possibilities are endless. And I find, because of acrylic's fast drying time, I can correct mistakes with alacrity and learn all the more quickly.

Glazing and Layering

A basic grounding in the techniques of the acrylic painter could well begin with glazing or layering. This versatile method has such wide application that it is, in fact, difficult to imagine painting in acrylic without some form of glazing. Simply put, glazing involves applying a transparent layer of paint over another layer that has dried. There is virtually no limit to the number of layers that may be built up or to the effects that may be achieved. Building enough layers to efface the texture of the support and make a slick surface facilitates the blending and softening of edges as you paint. A transparent glaze will alter but not obliterate the color (and value) that it covers. Multilayering can produce rich depth and subtle nuances. An opaque layer of paint can obscure the colors beneath, and therefore can be used to make corrections.

Linda Kooluris Dobbs, **Cretan Window With Geraniums,** *40″ × 28″*

BUILD BRIGHT COLORS WITH GLAZES.
"For glazing," Kooluris Dobbs says, "I use lots of medium and water with little paint. You must wait for one layer to dry before applying the next, or you risk streaking. After a glaze is applied, fingers can be used to blend.

Photo: Erik Redlich

TRANSLUCENCE AND TRANSPARENCY
These two sets of circles show the effect of water and gloss medium on acrylic paint. Although most acrylic colors are opaque, adding water gives the colors some degree of translucence, as we can see in the circles on the left. The circles on the right, similarly painted with two coats of color mixed with water, are more transparent because of the addition of gloss medium.

Layering Transparent Color

Nina Favata is happy with the effects she gets with transparent glazing in acrylic: "I am able to achieve a similar effect to that of watercolor, yet acrylic is far more forgiving, allowing greater flexibility to correct or change things and also to work in glazes. It also gives the rich effect of oils when used with the proper mediums, without the involved cleaning, heavy odors and drying time."

Favata begins with "clean, basic colors" over which she glazes a transparent layer and a finished coat of gloss-medium varnish. This technique imparts to Favata's work a warm and inviting glow. Achieving the warmth and cleanness of her colors is facilitated by the use of a color chart of her own construction. "In using your color chart," Favata advises, "mix your colors in advance so you have less trial-and-error and less chance of ending up with muddied colors."

In the event that Favata makes a mistake in color placement, she mixes a wash of titanium white and water and builds over the area with the wash, being careful not to lose (fill in) the tooth of the support. After assuring herself that the wash is both smooth and dry, she simply paints in her correction.

Nina Favata, **Beverly's Garden,** *22″ × 30″*

USING TRANSPARENT WASHES. *Nina Favata enjoys the range of expression and techniques that acrylic affords her. Here she uses transparent washes like she would watercolor, but without fear of lift-up. She enhances her work with richness without the use and smell of solvents.*

Nina Favata, **First Avenue,** *24″ × 28″*

NEUTRAL GRAYS THROUGH GLAZING.
Favata uses two color charts she has made herself, one showing tube colors, the other, favorite color mixtures. In painting First Avenue, *she relied heavily on a section of her chart that showed a series of grays composed of green and red. Though the charts are helpful in choosing colors, they do not help her much in glazing; she relies on experimentation, instinct and memory.*

Glazing Thinly With an Airbrush

Another artist who relies heavily on glazing for his finished effect is Phil Chalk. His approach is somewhat different from Favata's in that he uses an airbrush. Chalk chooses acrylic as his medium over slow-drying oils because he likes shooting thin layers of fast-drying paint. He also enjoys glazing with thin washes without disturbing the underlayer of paint (a virtual impossibility with watercolor).

Mistakes with the airbrush (unless caught early in the process) are not so easily corrected because of the velvet-like finish Chalk

achieves. Because of this and because his work is so exacting, Chalk relies heavily on his drawing ability to establish a clear guide for his multiple paint applications.

Among the many pitfalls of airbrush use is the likelihood that your paint mixtures will not look the same when sprayed onto the painting surface as they do in the jar. Therefore, it's always wise to test them before applying. The airbrush artist needs an astute understanding of the workings of color—and, of course, good equipment and a willingness to experiment.

*Phil Chalk, **Covenant**, 36″ × 46″*

SMOOTH CONTOURS WITH AIRBRUSH. *Airbrushing is a technique often associated with commercial art, and indeed many of our acrylic painters have put it to such use. Some use it, also, for smooth application of backgrounds in their paintings. And some, like Phil Chalk, create sensitive paintings with the airbrush, often in combination with other tools and media.*

Airbrushing With Acrylics

Chalk's technique is to mix a rather thick concoction of paint with matte or gloss varnish. Using twenty pounds of air pressure coupled with the thick consistency of his paint allows Chalk to work very close to his support without fear of his paint "fanning out." Of his chosen technique Chalk says, "Most fine-art airbrush work makes airbrush users look like they are only interested in cheap tricks and slick commercial images," whereas "a combination of airbrush *and* other tools is always more interesting and unique." Thus, beyond his expert handling of air, Chalk adeptly brings his work to completion with paint brushes and Berol Prismacolor pencils. This mixed media application helps Chalk to achieve the textures he's after. To this end, he also may scratch into his paper with an X-acto blade, which he may employ as well to cut the frisket he uses for masking his work while spraying. Any danger of accidental perforation of the paper is precluded by having the paper mounted onto Masonite.

PHOTO

Using colored pencils and brushes along with his airbrush, Phil Chalk will work an average of 130 hours to complete a painting. Referring to slides such as the one pictured here, and also drawing from life, Chalk manages to get this composition planned, mapped out and drawn in a mere twenty-five hours.

CONTOUR DRAWING

Next, Chalk makes a contour drawing of each of the many objects in the composition. These drawings are done on drafting film (rag paper), which he then coats on the back with graphite. The drawings are positioned on the support and transferred to it by retracing with a hard pencil.

STEP 1

After the drawing is transferred and toned down with a kneaded eraser, Chalk begins to block in the dominant background color. Using the airbrush freehand and barely pressing on the trigger, Chalk draws in the color very close to the outlines of his forms. This method, he says, "keeps most of the overspray from discoloring the areas that have yet to be painted. As I work away from these white areas, I begin to pull back on the trigger more to get wider lines that are easier to blend."

STEP 2

After completing the fabric colors, Chalk starts working on other patterns, such as the flowers and vines. Once he has "fine-tuned" the background, he begins to render the crisp foreground objects, protecting the softer background with tape and paper masking.

STEP 3

Chalk now focuses on the eggs, which he freehands, using cool and warm violet with pure ultramarine blue for modeling the forms by means of shadows. A light wash of raw sienna on the lighted side enhances the roundness. Working in the lower left, Chalk masks off an egg to prevent overspray. He explains, "The flower petals and leaves that are closest to the egg and along the edge of the fabric are painted while holding up a curved piece of card stock to make hard edges and control overspray. (This technique is called shielding.)"

STEP 4

The shadows and the white table in the corner have been completed, as has the fabric around the egg (except for fine detailing with brushes). After pulling off the frisket that was masking the egg, Chalk applies the negative shape of the frisket that surrounds the egg. This will protect the bordering areas as the egg is sprayed with paint.

STEP 5

Chalk begins to paint the paper flowers using bright, pure tube colors, and models the folds in the paper with the shadow colors he mixed in Step 3. After studying the composition for a day, Chalk makes his decisions regarding the color and color temperature of the marbles. He chooses warm colors for those in the foreground and cool colors for the background ones, explaining, "This, I felt, was a more natural way to create a visual movement that led up to the bright flowers, since warmer colors advance and cooler ones recede."

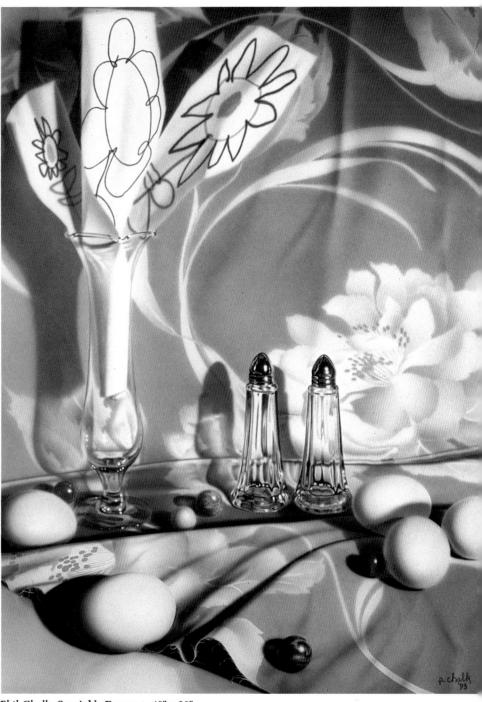

*Phil Chalk, **Seraiah's Bouquet**, 40″ × 30″*

FINISH. *"Finished! Actually, I studied the painting for several days,"* Chalk explains, *"and added a few polishing touches before signing it and calling it done.* Seraiah's Bouquet *took about 155 hours to complete, counting the drawing time. Painting alone was about 130 hours."*

Glazing Loosely on a Firm Foundation

Robert Bissett is an artist who utilizes glazing to its fullest potential. His expertise was not easily won, but as a Vietnam veteran, he had learned never to give up. Drawing on this ingrained attitude enabled Bissett to embrace the challenge of mastering a new medium.

Of all that Bissett has learned as a painter, perhaps his most unshakable conviction is that the most important part of the painting process is the foundation—the composition

or design, and the "map" of values and colors. I know, having worked in construction, that a house does not stand because it is nailed together, but rather by its own weight bearing down on a level foundation: bad foundation—shaky house. In painting, Bissett starts with the groundwork, and until his blueprint is crystal clear, he does not even consider his choice of colors, focusing instead on shapes, values and two-dimensional design.

*Robert Bissett, **Tucker**, 36" × 40"*

START WITH A PENCIL STUDY. *As always, Bissett started out with a preliminary value sketch, followed by a small-scale color study in acrylic. Even after these preparations, there is still room for the unexpected; but in this case, the painting proceeded according to plan.*

Experimenting With Colors, Values and Shapes

Once the fundamentals are set in a scaled-down pencil study, Bissett sets out to work with the understanding that mistakes are an expected—and welcome—part of the painting process. Working on Masonite-mounted watercolor paper or gessoed canvas, Bissett first uses thin paint. This is his wash-in stage, and it is deliberately loose and sloppy, usually done with a window-trim brush. "Now there's plenty to correct," Bissett says. "All the corrections except the final ones are mistakes. I keep everything as loose as possible and in a state of flux; nothing is final until the end."

Bissett will continue glazing and layering paint, making mistakes and correcting them. He will experiment with color, values and shapes, as well as proportion and the sense or feeling of the pictorial relationships. "Experiments that work are retained on a trial basis because something better may happen. I remain willing to risk everything to make a painting better. This process takes you to the limit of your artistic vision and aesthetic judgment." For Bissett, the process of changing shapes and colors through the natural evolution of layers leaves wonderful residues that might not ever have occurred if they had been intentional in the design.

WATERCOLOR STUDY
Robert Bissett begins by shooting some reference photos of his friend and fellow artist who farms in the old way, with horse and plow. Over a period of a few days, Bissett works out a painting plan by means of a detailed drawing and this watercolor study of the hands.

STEP 1
A tracing of the drawing is projected onto a 34" × 30" Masonite panel covered with several coats of gesso. Raw sienna is used to wash in the major masses with an old no. 3 synthetic bristle brush.

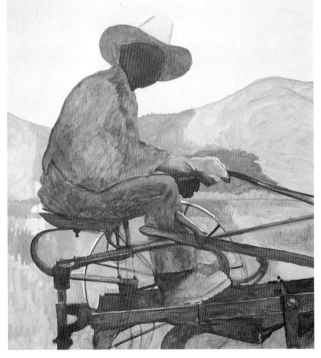

STEP 2
Using a palette of manganese blue, ultramarine blue, raw sienna, burnt sienna, viridian, ivory black and titanium white, Bissett first makes passes of very fluid paint. After pausing to evaulate, he defines each major mass in the background before painting in the entire image. Color and value corrections start to shape up.

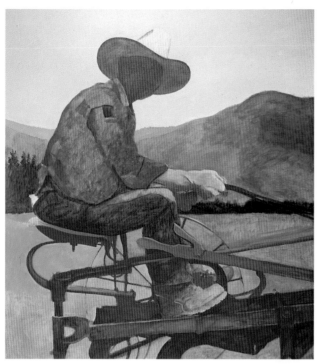

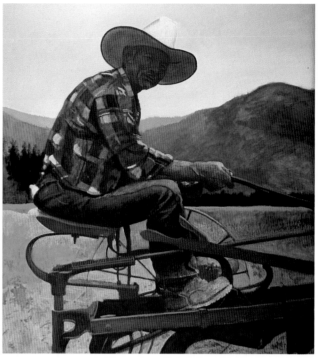

STEP 3

After another pause to evaluate, Bissett begins with a manganese blue, yellow oxide and white wash for the sky. The mountains are modified by the addition of Prussian blue and white. Adjusting and readjusting the colors of the sky, mountains, earth and plow, Bissett returns his attention to the sky, which he gives two coats of manganese blue, cadmium lemon yellow and white. A darker mixture is used for the distant mountains. During this phase, everything will be tested, evaluated and built up with several layers of wash and the introduction of new colors.

STEP 4

Bissett decides that the values of the painting now match those of the pencil study, and he can concentrate on developing the right color harmony and temperature. He experiments, trying many glazes on the skin and clothes to make sure that no one color overpowers its neighbor. The distant field receives more washes, and the plow is darkened. The face and hands are more defined and are glazed over with burnt umber to moderate the redness. Now, Bissett sees that the crown and brim of the hat need to be corrected.

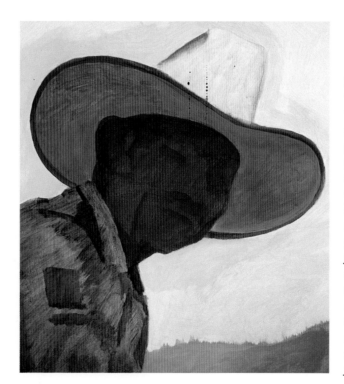

DETAIL

The shadow of Ted's hat brim receives a mixture of yellow oxide and prism violet. The shirt is washed with manganese blue, cadmium red deep and white to gray it slightly. The face in shadow is washed with cadmium red light. Keeping his eye on the total, Bissett does not yet attempt to detail the features of the face.

DETAILS

"Burnt sienna and white are used to restate the light areas of the face, followed by a glaze with Indo orange red mixed with cadmium red deep. The areas in deeper shadow are glazed with quinacridone purple and black. This sequence is repeated until the face is more defined and in better balance with the hands," Bissett says.

Robert Bissett, **Ted on the Plow,** *34″ × 38″*

FINISH. *"A strong procedural approach has given me the opportunity to exercise an intuitive sense of color and value based on inner feelings and informed by the elements and principles of art in a controlled and logical manner," Bissett says.*

*Joseph Orr, **Evening Glow**, 35" × 51"*

THINNER PAINT FOR DETAILS. *Joseph Orr says, "The utilization of a variety of techniques is, for me, the most fun part of painting." In the first stages, Orr is almost sculpting with his paint. In the latter stages, his palette becomes thinner for detailing. "At this point, the work consists mainly of filling in detail such as tree limbs, blades of grass and the more intricate points of the painting. I use very thinned transparent color for glazing where I want to add depth (for shadows or water, for instance) and to tie the color together."*

Combining Thick and Thin Layers

Although he makes splendid use of the technique, Joseph Orr has a limited need for glazing. He uses it effectively, sandwiched between heavier layers of paint, as well as for finishing touches. "I find acrylics to be more congruent with my painting personality than watercolor," Orr explains. "Acrylics appeal to my need for a 'heavier' and more permanent medium." Using gloss-medium varnish as his finish varnish, Orr dilutes his paint with water only. "With my approach, the strength of the acrylic medium is in using it like oil paint, then interspersing some glazing techniques in the painting process. The medium's versatility is in its ability to combine thick and thin applications on the same support."

Orr also enjoys the fast drying time, the lack of chemical hazards, and the workability of acrylic when painting outdoors. He will go out scouting with paints and small gessoed Masonite panels for field studies. Back in the studio, Orr works on large, cotton canvases. Like Bissett, Orr uses a house-painting brush, as well as some other favorites, such as a no. 1 nylon rigger, no. 8 filbert, no. 2 and no. 12 flat bristle, and no. 1 and no. 2 round bristle, along with a triangular painting knife.

*Joseph Orr, **McWilliam's Bird House**, 36" × 51"*

"SCULPT" YOUR PAINT. *After determining the direction of the light and planning the values, Orr says, "I worked from back to front (sky, hills, etc., up to foreground). I 'scoop' the paint onto the brush and apply it heavily to areas where I want a textural effect, so I am almost 'sculpting' it on the canvas."*

Detail With Drybrush and Hatching

DRYBRUSHING

Crosshatching and drybrushing techniques put many textural possibilities at your fingertips. Here, yellow is drybrushed over red mixed with gel for texture.

Combining thick and thin is also part of Dean Mitchell's technique. But whereas Orr glazes a thin layer of acrylic between heavier ones in multiple stages, Mitchell begins with a thin wash of watercolor-plus-matte medium as a base coat for his acrylic painting. To complete the painting, a final glaze of the watercolor mixture serves to soften or tone down the acrylics, enhancing the mellowness of the mood.

Mitchell combines not only different mediums and paint layers of different consistencies, but a variety of techniques. His glazing process is capped off with careful drybrush work and crosshatching, done with a very fine brush, to create surface texture and the illusion of depth. Drybrushing involves lightly draw-ing fairly "stiff" opaque color across the painting surface with a brush. Drybrushing can be used dark-over-light as well as light-over-dark to optically merge or blend colors on the support. Crosshatching is done by overlapping fine crisscross lines in one or more colors.

We can also see these thick-and-thin techniques used with a different effect in the work of Mark Jacobson, whose extremely direct method attests to his mastery of seeing as well as painting. Jacobson begins his paintings with either thin washes on a white canvas, or more opaque colors blocked in on a color-toned canvas. The opaque approach is a sort of short-cut that bypasses the initial washing phases.

*Dean Mitchell, **Deer Skin**, 14″ × 28″*

ADD EGG YOLK TO ACRYLIC. *Dean Mitchell here employs the techniques of crosshatching and drybrushing so familiar to painters in tempera. He has even combined one of tempera's elements, egg yolk, with his acrylic and watercolor palette.*

*Mark Jacobson, **On the Edge**, 32″ × 30″*

PLACE DETAILS WITH THIN WASHES. *To establish areas on his support, Jacobson started with thin washes, in which he set even the details into place. Next he filled in the areas with opaque paint, obliterating some of the detail, which he re-established in the last stages of painting.*

Veiling, Accenting and Highlighting

On a white canvas, Jacobson usually starts with a thin "wash-in" that is a full-color version of the final painting, but transparent—almost like watercolor. Jacobson uses water to dilute his paint for the first few layers. Later, while building up details, he will add his painting medium, which consists of one part gloss medium, one part matte medium and three to four parts water. Synthetic sables, brights or filberts are used for flat layers of paint, but his brushes will gradually reduce to size 0 rounds for detail.

"Over the wash-in," Jacobson says, "I do a second major layer, which could be called a 'block-in.' Here, I'm using somewhat thicker paint, using the wash-in as a guide, and trying to establish the large and medium shapes with more opacity than in the first layer. The final layers involve small details, light-over-dark and dark-over-light using the pointed 0 sable," and patient cross-hatching.

Toward the end of his painting process, Jacobson will often glaze over certain areas with a translucent wash of color to darken or lighten values or to blur out areas that may have become too strong or over-whelming. This process, called *veiling*, can also deal with misplaced or premature detail.

The artist adds the finishing touches with accenting and high-lighting, strategically adding small strokes of dark or light pigment. About the use of these techniques, Jacobson says, "I like to finish a painting by putting small patches of purple here and there. The purple tones give somewhat of an 'impressionistic' touch to the work, and final highlights balance out the composition and help the eye move from one area of the picture plane to another area in a smooth, more graceful manner."

PRELIMINARY STUDY

For some time, Mark Jacobson cherished the idea of painting this church near his home. He did a quick study on canvas board, using only black and white, to see if the image on canvas would bear out the one in his mind.

COLOR STUDY

Next, Jacobson introduces layers of semi-transparent color over the monochrome, letting the gray tones show through here and there. He finds that the "surreal" look he envisioned is not going to work. He decides a more realistic and subtle approach is needed in the final painting.

STEP 1

"I decided to try for a feeling of glaring sunlight, rather than gloom, and a black cat lurking somewhere in the shadows, rather than the figure," Jacobson says. Toning his canvas, he does a rough drawing and blocks in shapes with tonal values.

STEP 2 (left)

Jacobson is still painting rather loosely and keeping his eye on the abstract design of light and shadow. "I've started to block in some of the middle tones on the grass and bushes in front of the church, and have added middle tones and lighter shades to the trees on the right. The shapes are abstract, and there is only a hint at a smooth graduation from light into shade," he explains.

STEP 3 (above)

Jacobson develops his light areas quickly with three layers of paint. He starts his progressions from shadows to middle tones to light. "The shadows only have been blocked in on the right side, halftones have been brushed on next to the shadows farther along the bushes [red arrow], and the lighter tones have been added to complete the basic procedure [white arrow]," he says. Keeping the lights dull now will allow him to define individual shapes later by going yet brighter and adding a little dark for greater contrast.

STEP 4 (left)

Jacobson's process might be called "middle of the road" in that he doesn't splash around or jump right into detail. He likes to work up the entire surface at once. As he adds middle tones to the church itself, the steeple gets a little more "finish" than he wanted. This happened, he says, "because I liked the texture so much that I started using smaller brushstrokes over the basic light, halftone and shadow. Perhaps not a mistake, but I really should have waited until the entire canvas was blocked in first!"

STEP 5

Details of the stone work are blocked in, and things are taking shape. The circular window receives some halftones and light, and the roof is brushed in fairly flatly with no detail. The sky is brushed in, and the last background tree has been blocked in. "Once again," Jacobson says, "I've jumped ahead a bit, putting some smaller brushstrokes over that background tree in a rather quick, spontaneous fashion. This already makes it smoother in graduation from light to dark."

STEP 6

Jacobson places stick-on letters to mark his trouble spots. Some examples: "The leaves are a bit distracting where they help frame the church. The progression from light to dark needs more smoothness." Also, he finds "the shapes on the road need to be changed a little, and subdued. These 'spots' can generally be taken care of by glazing over them (veiling). I'm also going to strengthen the light area around the doorway, which is the brightest part of the picture. This is called the effect, a sort of spotlighting that gives the painting more drama."

STEP 7

As Jacobson scurries about the canvas with glazes and opaque touches here and there, each element becomes more defined and characterized. Jacobson dilutes his colors with a mixture of one part matte medium, one part gloss and four parts water. This, he says, "gives the painting a more satin-like appearance as the work progresses. The trees are almost complete. More intricate touches are 'woven' onto the right side, suggesting additional branches and highlights."

STEP 8

Jacobson attends to the stonework, adding more texture where needed. With the painting nearly finished, it is time to place the cat. He says: "I draw the outline of a cat onto paper, then cut it out and color it with a black marker pen. By placing some tape on its underside, I can attach the cutout to various parts of the road, trying to decide where it looks best."

STEP 9

"The cat has been placed and painted in, and the stone column has been changed to light-against-dark. I've corrected some of the perspective on the column as well."

Mark Jacobson, **Lucifer Waiting,** *22″ × 18″*

FINISH. *"The painting is initialed and sent to a photographer for a 4 × 5 transparency. When I looked at the final slide, I decided to add some further touches of color to the trees, and possibly to the roofs. It's back to the studio again, for a little more work."*

Brad Faegre, *Old Tracks That Go Nowhere Now*, 24" × 30"

IMPASTO TECHNIQUES WITH ACRYLICS. *For some artists, switching tracks from oil, watercolor or another medium to acrylic can be unsettling. Brad Faegre was not sure at first that his retraining was going to prove fruitful or enjoyable, particularly due to the fact that he likes to lay paint heavily.*

Opaque and Impasto

An effect very different from glazing is achieved by the laying down or layering of opaque colors. Dry-brushing or crosshatching with strokes of opaque pigment allows the layers beneath to peek through and interact with the surface colors. Paint can also be applied in a thick consistency that will dry dense and smooth (opaque) or textured with brushstrokes (impasto). Paint can be heavily built up with a brush or palette knife so that the textural or sculpted elements play an important part in the overall effect of the painting. As with all acrylic techniques, opaque and impasto painting can be approached and handled quite differently by different artists, as is the case with Brad Faegre and William Hook.

Brad Faegre, *The Wash*, 12" × 18"

KEEP OUTDOOR PAINTINGS SMALL. *Once Faegre got a handle on the medium, he looked out at new horizons and soon realized that the sky was the limit. Faegre's fear of the paint drying too quickly was an impediment until he learned, as he says, "to accept the fact that the paint dries fast and use it to my advantage; and second, to keep the size of the support small when working outside in an arid climate."*

Shape-Making

For many years Brad Faegre used his acrylic paints almost exclusively as a preparatory or sketching medium. He rarely used them to tackle large supports. Rather, he considered acrylics a marvelous medium for making quick sketches in the field, which he could then bring back to the studio and use as reference for larger paintings in other media. Having painted in oils for many years, he found that the adjustment to acrylics as a "full-fledged" fine-art medium was not easy.

Faegre recalls: "My first experiences with acrylics were frustrating. I recall the feeling of being rushed. The fear that I wouldn't get the paint to do what I wanted before it began to congeal always seemed present." In time, Faegre became comfortable enough doing small studies in acrylic—so comfortable that he felt the need to rouse himself from complacency and try again. "I recall wrestling with the medium the first couple of days. I began experimenting with commercially manufactured retarder, adding it to the colors in a vain attempt to transform the medium into something more familiar to me."

Not much later, he suddenly realized that he was making quicker decisions. "I was no longer frantically pushing the paint around, hoping I would do something I liked with the brush before the paint congealed. I was planning the shapes my brush would make beforehand, and this concern for shape-making was producing visual interest throughout the painting. I liked what I was seeing." At this point, Faegre stopped expecting his paints to act like oils. No more mixing on the support, no more wet-into-wet. "Instead, I was beginning to treat the medium as an exercise in thoughtful accumulation—building color upon color, stroke on top of stroke."

PASTEL STUDY
After hiking into the hills and viewing the terrain and distant mountains, Faegre painted a small study in pastel showing the late afternoon sun bathing the land in warm hues. In painting the scene, he says, "My purpose was to communicate the mild yet pleasant melancholy I feel at this time of day."

STEP 1
On a support of black gessoed Masonite, Faegre makes a rough sketch, using the pastel study as a reference.

STEP 2
"Additional colors begin to define the shapes of distant mountains, local hills and trees."

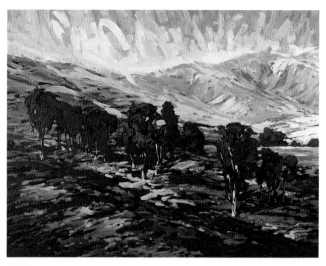

STEP 3

"More and more paint is applied to define shapes and describe the surfaces of objects," Faegre says. *"At the conclusion of this stage, the painting should be approaching completion. However, in this case, it does not come close to communicating my original idea: the feeling I associate with the end of the day. Substantial changes are necessary."*

STEP 4

Faegre uses black to redefine the shapes of objects he finds uninteresting. Then he focuses on the sky and distant mountains. He says, "I begin to transform the overall feeling of the painting by adding warm, intensified hues to the sky, foliage and ground. My goal here, as it always is, will be to make an exciting painted surface that has the potential for drawing the interest of the viewer away from the painting's subject."

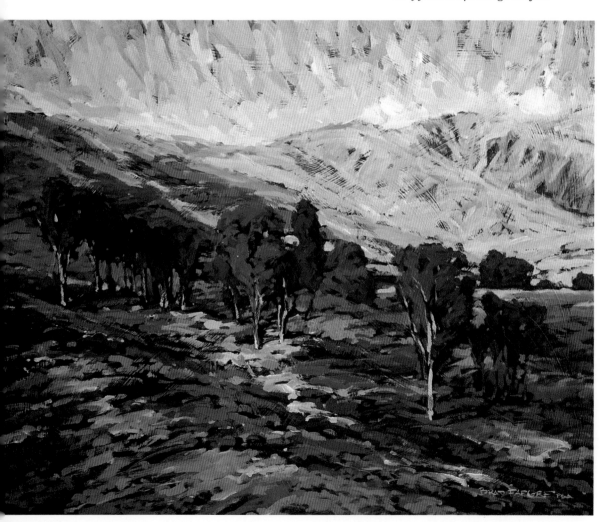

Brad Faegre,
California Winter,
24" × 30"

FINISH. *Evaluating the results, Faegre concludes that "with a more active and interesting sky, a softer treatment of the distant mountains and warmer overall color temperature, the finished painting has benefited much from the reworking."*

Creating Texture

Whereas Brad Faegre began to enjoy acrylic when he stopped trying to mix his colors on the support in the manner of oil painting, William Hook finds that blending on his canvas works well. The secret, he says, is to have paint that is heavy, not watered down too much. But he does not start right in with thick layers, for any texture caused by brushwork or stiff paint in the early stages will be an impediment to working subsequent glazes or layers. Stated

simply: Texture should go on the top, not the bottom, for easiest handling and best pictorial effect. Hook, therefore, begins his work with a wash. He develops his middle values first, and allows the lights and darks to evolve from there. His washes will eventually be covered with a drybrush or impasto technique. The texture, Hook believes, can help the validity of an object rendered in paint.

William Hook, **Tesuque Still Life,**
24″ × 24″

BUILD TEXTURE SLOWLY. *William Hook uses an impasto technique for its visual effects. He cautions, though, that starting out with impasto in the first layers of paint on your support may create passages that will be difficult to "cover." Hook, instead, builds up his textures slowly, letting the paint accumulate by degrees under his watchful eye.*

Scumble, Spatter, Smear

Scumbling is done by thinly brushing opaque or semiopaque color, usually in short strokes or swirls, over another color to reduce its brilliance or to soften or blend areas of color. This can be done with a brush, knife, sponge, paper towel or, for those who really like to get their hands in and "mess around" with their paints, fingers (whatever works!). For *spattering*, a toothbrush is a handy tool with which to flick flecks of color onto your painting by running your finger over the bristles. Even drips, accidental or intentional, can be incorporated into the design.

A Rhythmic Use of Color

Linda Kooluris Dobbs enjoys stylistically giving a contemporary face-lift to traditional subject matter using acrylic techniques. When an allergy to turpentine ended her short working relationship with oils, she happily fell in with acrylics. She states that from a production point of view, "it dries fast, and works can be presented, sold, shipped or reproduced quickly."

Kooluris Dobbs's rhythmic use of color is a key to her virtuosity. She works with a full range of colors that she mixes from the primaries, plus others she cannot make, such as turquoise or magenta. She will paint on

*Linda Kooluris Dobbs, **Bruce Cockburn**, 13½" × 20"*

BLENDING GLAZES BY HAND. *For the glazes here, Linda Kooluris Dobbs used lots of medium and water with little paint. To avoid streaking, she made sure the paint layer was dry before applying the next one. Once a glaze has been laid down, she often uses her fingers to blend.*

anything from paper to linen. Her brushes include Winsor & Newton Series 7 watercolor brushes, Art-Tec Gold Sable 610 and 640 series, and, lately, some Grumbacher Bristlettes in varying sizes, of which she says: "They really hold the paint well and don't hold too much water." Kooluris Dobbs has found that "when painting on paper, the acrylics are absorbed very quickly into watercolor paper. You may need to mix them with or paint over them with acrylic medium, or water them down."

Kooluris Dobbs places her colors on the palette "in the order of the color wheel, from light to dark to avoid contaminating and killing adjacent colors. I never use black to make my grays, finding mixes of complements more radiant and beautiful. Remember, no color exists by itself; its neighboring colors make it sing or kill it."

For blending colors, Kooluris Dobbs finds that her fingers work very well. She employs a toothbrush for spattering. This method of fine misting can be very beneficial in both optical mixing and textural illusion. But when splashing your paint around to create effects, you want to take care not to spatter untargeted areas of your work unintentionally. Kooluris Dobbs accomplishes this by masking off her work with waxed paper, which is both nonabsorbent and somewhat transparent so that she doesn't lose sight of the overall picture. If you spatter with paint that is either too heavy or too light, you may get an undesirable effect. Such an accident can be absorbed with the point of a paper towel or wiped off with a clean, wet towel.

Kooluris Dobbs enjoys the freedom to express herself spontaneously with acrylic, knowing that "if you stick to colorfast colors and use a final varnish, you can expect your work to last way beyond a lifetime."

Linda Kooluris Dobbs, Majolica & Frutti, 11" × 16"

MATCH YOUR STROKES TO THE OBJECT. *To round out or reinforce a shape, Kooluris Dobbs says, "Make your strokes move in the direction of the surface almost as if you were polishing it."*

Linda Kooluris Dobbs, Adam & Regan Phillips, 40" × 52"

USE GLAZES TO SHOW DISTANCE. *"The addition of darker glazes (often complements of the base color) acts to push an area back in space (as in the water contours), whereas adding a lighter color or white or a mixture of both, thinned out in a glaze, pulls an area forward (as in the lighter areas of skin tone). Hardening an edge also pulls a shape forward, while softening an edge shortens the distance between shape and background."*

Use Inventive Techniques

The work of Helen Schink, strikingly modern in its imagery, is daring in its process, in which enthusiasm is coupled with deliberate experimentation. Schink has fun with a grab-bag of inventive techniques, from which she may pull out one or a whole assortment to use on a particular piece. About the most that can be predicted is that she is likely to start a painting on a wet piece of paper. She may use alcohol—which ordinarily serves as a method for removing dry paint in the correction process—to create a wet-into-wet effect. Included in her repertoire are glazing, denting, scratching, spattering and blotting.

Breaking the Rules

Schink leaves herself open to the idea of a "new happening" every time she approaches her white sheet of paper. Though I've been a painter and a student of art for forty years, I find myself impressed by the elusive spontaneity evident in Schink's work. To study Schink's visual expression is to understand that it's OK to break all the rules—as long as you know what they are. And Schink has probably forgotten more of them than I've even learned! But I'm still working at it!

And I have found, through the process of painting one painting

*Helen Schink, **Wind Swept Beach Pines**, 29″ × 21½″*

USING WHATEVER WORKS. *Helen Schink began this painting by applying color on a wet surface, then blotting with tissue to create forms and shapes. She scratched into the paint with a palette knife, allowing the paint to dry, and then applied alcohol to scrub out areas in the tree mass. The shadows of blue on the beach and dunes echo the blue in the sky for a harmonious effect.*

*Helen Schink, **Wild Strawberries**, 14½″ × 17½″*

LAYERS OF SPATTER. *Here Schink starts by painting the center of the support white, then forms the rocks by adding sienna around a lavender glaze. She uses spattering to break up some larger shapes into small pebbles. After glazing over the entire painting with light blue, she spatters again. The focal point—the white flowers—is blotted and detailed with a small brush. Finally, the small leaves are added.*

after another as fast as possible, that my work not only gets better, but also is starting to surpass my expectations for the medium. Every accident becomes an opportunity to experiment; sometimes, I can even happily combine one accident with another.

Accidental Spatter

For instance, while working on a picture, I inadvertently spattered some paint right onto a wet passage. Knowing that I would not be able to pick up the intrusion without disturbing the underlying work, I stood in silent panic for a few moments wondering if I didn't want to pursue some other avocation. But sensing that I was not about to escape from reality, I grabbed a palette knife and helplessly started smushing the beads of paint around as if they would magically go away. They didn't. But what they did do was to give me an almost effortless passage of optical blending. And I like effortlessness. So with much glee and prance in my step, I masked off "clean areas" and continued my adventure into splashing, pausing and smushing.

Any Method Is Fair

I have always had the philosophy that a good painting paints itself. The fewer conscious decisions I make, the better the result. I am all for power-sanding paintings, throwing wet ones into the snow, or any other method that creates the work. Does this worry me with doubts about my artistic virtuosity? Not at all. It's my work that is the important thing, and I will use any method to obtain a good result (and acrylic affords me that!).

Photo: Erik Redlich

SPATTERING

The photo on the left shows how spattering paint with a loaded brush over a painted surface can produce a spontaneous effect. After spattering and letting the paint start to set up, you can push it about with a palette knife or any other tool you like for wonderful textures as well as blending (as shown in the photo on the right).

Photo: Erik Redlich

USING THE PALETTE KNIFE

Some painters like to deliberately place each micromillimeter of paint, while others enjoy spontaneously washing, splashing or pushing the paint around. One can "smush" with a deliberate plan, or with a willingness to see what happens as I did to create texture in Rhode Island Blue *(see finished painting on page 86).*

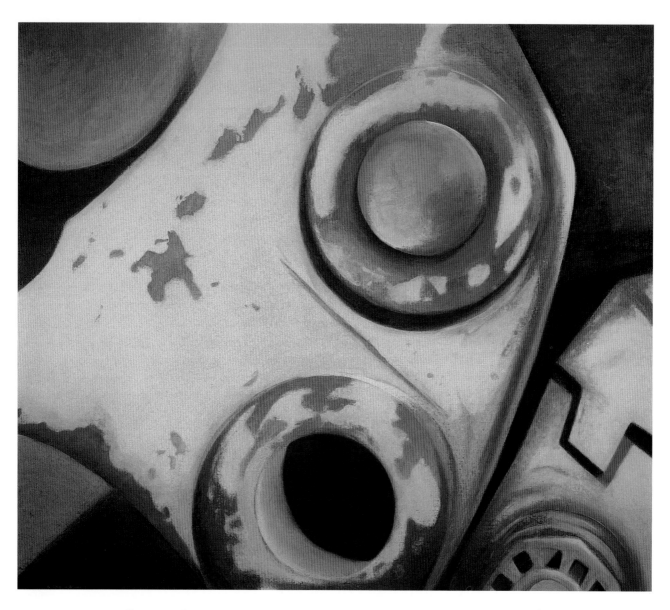

A Few Simple Tools

In my persistent search for the means to bring about a good result, I have ended up using fewer tools than I began with. From a plethora of assorted oil and watercolor brushes of varying fibers, my tool collection is now diminished to various parts of my hand, a palette knife and two brushes: a no. 8 nylon flat and a 0 round to sign my name.

Hands and Fingers

A soft stencil brush works miracles for glazing, blending and scumbling, but for these processes (and more) I've "progressed" to painting with my fingers and hands. This technique relies on assessing the receptivity of your support. To create a very smooth, subtle blending, the paint surface must be "slick," filling the tooth of the support. Rougher scumbling, where the colors dance with each other to create visual texture or optical blending, can be done on a toothy surface.

When I use fine portrait linen with a small grain or tooth, it takes me a dozen layers of paint to get the tooth filled and the paint surface slick with a traditional brush technique. Using other tools, I have

Earl Grenville Killeen, **Dances With Buffaloes,** *40″ × 52″*

ACCIDENT BECOMES NEW TECHNIQUE. *Accidental spattering in the lower-right-hand portion did not spoil the picture; instead, it developed into a new technique ("smushing") that has become for me a mainstay method of optical blending.*

various options, depending on the effect I'm after. For instance, if I need to end up with a harmonious glaze as a finish, I very quickly fill the tooth with a palette knife. Then, applying the last two or three glazing coats with a soft flat (brush), I rub the paint around with my fingers until it's dry.

Since a smoothly blended finish depends on a "slick" working surface, I use a lot of medium varnish with my paint. Varnish in the underlayers also allows me more working time with the final coats. This is because, unlike paint that is either straight from the tube or watered down, paint mixed with varnish creates a *non*porous surface on which my colors can be manipulated rather than quickly absorbed.

I find my hand quite useful not only for glazing but also for textural scumbling. This is generally done with the heel of my hand over paint applied with a knife to create a soft effect. For a rougher look, I use the knife alone.

The Palette Knife

In many ways, the palette knife is my best friend. For example, when I mask my work with tape, a ridge of residual paint is often noticeable where the tape has been removed. With my knife, I'm able to flatten the ridge into the paint passage, always keeping my paint layers even throughout the surface. Any flaw, such as a ridge or particle of dry paint, will become more amplified with successive layers of paint, so it's best to deal with imperfections in your surface immediately.

And it is immediacy that is the key ingredient in learning the acrylic medium. That is, you've got to get your hands in and work—or perhaps I should say *play*—with your paints. Relax your expectations, attune your senses and let the paints tell you what they want to do.

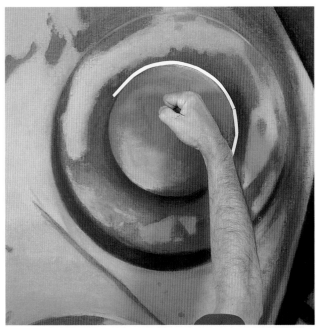

SCUMBLING WITH HANDS

Using my hands and fingers to paint has made my brushes all but obsolete. Depending on the depth of tooth on your support, there are any number of fascinating results—not to mention a resurgence of childlike glee—to be achieved with "fingerpainting."

Photo: Erik Redlich

Photo: Erik Redlich

PITTING WITH A PALETTE KNIFE

One of my favorite textural delights is pitting the surface of my paint film with drying paint that collects on my knife. I then drybrush over this surface with a lighter color. The effect is a more natural reflection of light, more diffused than slick.

Flexibility of Acrylics

Some of the techniques we've seen in our acrylic gallery may seem more traditional, others more modern, adventurous or even outré. Though some, like airbrushing, impasto and fingerpainting, may seem tailor-made for acrylics, many have valid application in other media that predate our polymer paints. Practitioners in any medium may range from conservative to avant garde in the techniques they rely on and the experiments they try. And in any medium there are rules you can't break—even bending them may be risky in terms of the successful completion of a piece and its longevity.

But acrylic gives greater flexibility than other media, which are bound by their physics and chemis-

tries to more limited usage. Watercolor, for instance, tends to be painted on a fragile support, needs the protection of glass and fades in sunlight. Oils have a composition prone to decay, and when not used as *originally* intended (that is, straight from the tube to the support in a single, direct application) can suffer a premature demise.

Difficulties With Oils

Early experiments with glazing in oils opened a Pandora's box for artists in this medium. Oil paint does not wish to be diluted with turpentine or layered so that there is an opportunity for the surface-paint film to dry, sandwiching volumes of varnish. Moreover, when oil

*Earl Grenville Killeen, **Rhode Island Blue**, 40" × 52"*

LAYER UPON LAYER OF GLAZING. *The challenge in this picture was to combine soft transitions of light to dark and at the same time impart a sense of age and "usedness." This could be achieved only by layer upon layer of glazing, to suggest new over old and old over new (such an amount of glazing would make an oil painting so brittle that I would not dare look at it too hard—any vibration may crack it).*

painters interpret the rule of painting "fat over lean" to mean putting down a heavier coat of paint over a thin one, they are getting the idea only half right. The true essence of this adage is to apply colors with low oil content to your support first, followed by colors with heavier oil content—ideally, all in one sitting. Such a practice serves the longevity of the painting, first by allowing less oil to attack the support, and second, by allowing the painting to dry evenly from the back to the front—which, by the way, should be done in total darkness for six months to a year (oil painters need framers with patience). Improper glazing methods lead to cracking, peeling and the need for restoration.

Two Rules You Can't Break

On the other hand, experimenting with a medium is certainly to be encouraged. It's prudent to remember, though, those "rules you can't break"—which, in acrylic, are essentially two: Don't dilute your paint *too* much, and don't paint on a slick support. I once experimentally used the wrong ground for an oil painting. A few days after my painting dried, it slid off the support and ended up as a heap of paint chips on the floor. You, of course, won't do anything so silly! Remember the few basic rules, try out a variety of acrylic techniques, and experiment to your heart's content.

Earl Grenville Killeen, **Eve and the Serpent,** *36″ × 45½″*

PAINTING OVER VARNISH. *In the course of painting this subject (the arm joints of a bucket loader), my colors got out of hand and I lost the sense of "seduction" that I wanted to convey; the two forms stood very independent of one another. To unify them, I added a little burnt umber to my main body color, and combining a few drops of this mixture with a lot of gloss varnish, I coated the entire surface of the picture, using a house-painter's brush. I then rehighlighted, with no fear that the last application of paint and varnish would fall off the varnished surface.*

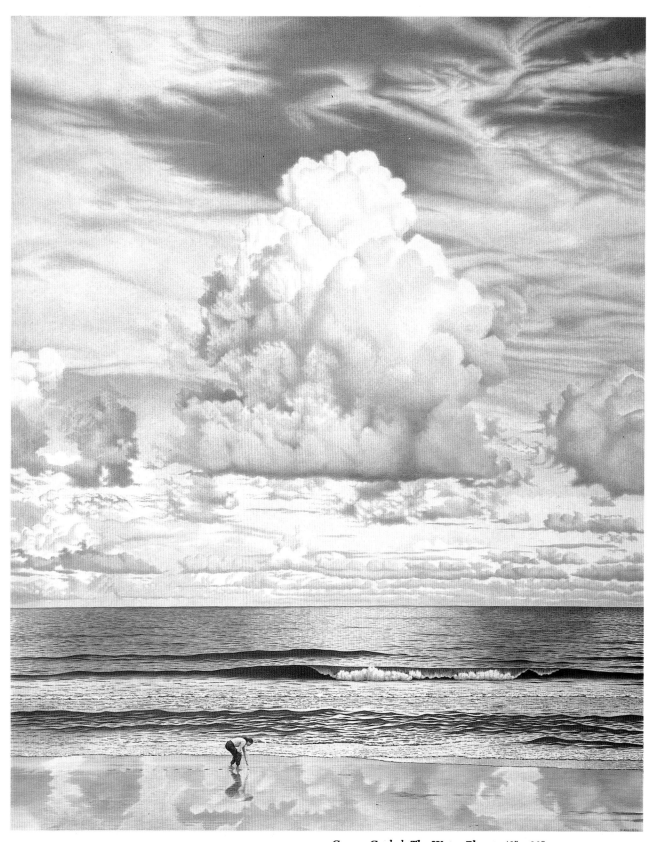

*George Goebel, **The Water Planet**, 40″ × 32″*

CHAPTER FIVE

Application

Diversity in Style and Genre

The artists we've met in this book illustrate the fact that, although acrylic artists are all painting in one medium, they are using diverse techniques and applications to create works in a variety of genres, and expressing themselves in a number of styles. These artists also have something in common. Most of them have worked in another medium before taking up an acrylic palette. Very few of them woke up one day and said, "Today I'm going to be an acrylic painter." On the contrary, there was usually an outside nudge from circumstances or a friend. And yet, most now work exclusively in acrylics.

The paintings we've seen on the preceding pages are certainly evidence that acrylic is not *just* a hard-edge medium, or one that has to look like plastic. The wonderful diversity of the art and the artists themselves seems, paradoxically, to hint at some common link that bonds these artisans together. Perhaps it is the magnetic draw of the medium that holds its adherents with the fulfillment of promised versatility. As Penny Saville Fregeau expresses it: "The use of acrylics can assist the artist in creating a great variety of styles. For example, acrylics are a natural match for the impressionist who wants to have brilliant strokes of color juxtaposed in harmonious combinations. Likewise, acrylics can be used to create soft and subtle skin tones on a portrait piece. Acrylics can be applied in a very thick manner to accentuate brushstrokes, or can be worked absolutely smooth to look like the painting has been airbrushed."

Subject and Style

This chapter will explore the vitality and range of the acrylic medium in the hands of some of its enthusiasts. It will take a look at how the artists' use of materials, color and technique serves their own aesthetic vision and language, as these translate into choice of subject matter and style—styles that range from the intricate work of Penny Saville Fregeau and the Romantic portraits of Dore Singer to the tender depictions of Vicki Junk-Wright or the contemporary flair of Linda Kooluris Dobbs.

Penny Saville Fregeau, **Mother and Son at the Beach***, 18″ × 24″*

"THE FAST OIL PAINT." *Whether tackling an intricate still life or the human figure, Penny Saville Fregeau relishes the qualities of what she calls "the fast oil paint": blocking in with heavy layers; thinly glazing for the effects necessary to render reflections, fleshtones and minute details; and making corrections easily on a finished painting.*

Linda Kooluris Dobbs, **Edwin A. Goodman, O.C., Q.C., D.U.***, 36″ × 28″*

A CONTEMPORARY SLANT. *Linda Kooluris Dobbs brings a contemporary slant to even this "traditional" portrait, whose formality is mitigated by the hint of a smile on the dignified subject, the warm glow of the monochromatic background, and the playful zigzags that vie with the alabaster columns in the architectural design.*

Dore Singer, **Feeding the Rooster**, *7" × 5"*

TONE THE CANVAS FIRST. *Dore Singer's romantic portrait is radiant with soft light and vibrant colors. She began by toning her canvas with diluted warm colors, such as burnt sienna and alizarin, using a wide brush. Singer did a detailed sketch on tracing paper, and after the canvas was toned and dry, she used a carbon to trace the sketch onto the canvas. She worked from light to dark, building up the values and applying the highlights last.*

Vicki Junk-Wright, **Quiet Moments**, *3' × 3'*

GLOSS MEDIUM FOR LUMINOSITY. *The luminous quality of this tender portrait owes something to the gloss medium that Vicki Junk-Wright mixes with her paints. The dazzling patterns of color and light swirl around the calm island of the maternal embrace.*

Arne Lindmark, **A Walk on 53rd Street,**
22″ × 30″

PLAN YOUR PAINTING IN BLACK AND WHITE. *Arne Lindmark paints a variety of subjects, many of which include groups of figures. However, of less concern to Lindmark than the literal subject matter is the impact of integrating abstract shapes and values. To plan the value patterns, he always starts out with a careful study in black, white and grays.*

Painting the Figure: A Watercolor-like Approach

Arne Lindmark brings an abstract slant to a representational mode of painting. In his figurative work, design is of the essence. Flat shapes play off one another, given dimensionality by the interaction of values and a stylized hint of modeling. The colors, though, are *not* flat but energetically mottled and vibrant.

If Lindmark's works have a "watercolor look," it's not surprising. He's a veteran watercolorist who, some ten years ago, began using watercolors in combination with acrylics. While he enjoys using acrylics in a "watercolorist" way, he appreciates the ways in which acrylic outperforms its sister medium. He is able to manipulate his paints, like watercolors, with such tools as napkins, sand, salt and scraping, but is also able to achieve greater textural effects and to enjoy greater correctability and permanence in his work. Tinting and washing, favorite watercolor techniques, are in fact more practicable with acrylic paints, which stay put when you wash over them.

Acrylic's Tenacity

Because of acrylic's tenacity (as Lindmark puts it, "once it's down, it's down"), Lindmark carefully maps his values before applying color, doing precise value sketches. He begins, usually, on a sheet of 140-lb. cold-pressed paper, for texture. While he builds his values up from dark to light, he also incorporates textural elements with his brush, which will subsequently be glazed over. The only mixing he does is of a combination of three colors to make his darkest dark. Other than that, his mixing is done by the viewer's eye through his many layers of glazing. In keeping with his watercolor approach, Lindmark mixes only water—no medium—with his paint.

Nevertheless, as Lindmark himself says, he is "not a traditional watercolorist. I believe very strongly in using any medium as long as it does what you want it to do. I would use mud if it worked to solve an immediate problem. With acrylics used in conjunction with watercolor, I find the following points to be very important: If you need more chromatic strength at your point of interest, the staining quality of acrylics is very helpful. Underpainted textures and shapes are not affected by subsequent washes. Acrylics work with any watercolor technique you may use, such as wet-in-wet or glazing, and when dry, they are permanent."

Though Lindmark plans and maps his design and values carefully, he is not "tight" in his painting mannerisms—quite the opposite. His control is balanced with spontaneity. He will use drybrush and splattering "to cause excitement where excitement should happen, making the eye go where you want it to go."

Painting the Traditional Portrait With a Modern Medium

The human figure is also the subject for the art of Earl V. Guedry, Jr., a formal and traditional portraitist. In contrast to Lindmark, Guedry renders his subjects with fully realistic modeling and attention to naturalistic detail.

Guedry was first drawn to acrylics in college. He was struck by the fresh effect a fellow art student had achieved with this new medium. These impressions stayed with him, so that later, as he reports, "when I began to devote as much time as possible to portraiture, I decided to use this contemporary medium and make it work in one of the most traditional categories of painting."

Pursuing this goal, Guedry emerged as not only a master portrait artist but a proponent of this "fascinating and challenging" medium. He states: "Traditional portraits painted in acrylics have an immediacy that makes them seem more appropriate in today's houses. For some reason, perhaps because the painting techniques deposit fresh pigment free of oxidizing films, they seem to be more alive."

Guedry extols the virtues of the paints with which he has developed such a beautiful working relationship: "Acrylics allow the painter the greatest freedom in the application of paint to the ground. Any combination of colors—in any thickness or dilution—can be combined in any order, and the adhesion is secure. Corrections and changes, at any stage, can be made on the surface without complicated procedures to ensure stability." And he counsels the new student: "Careful planning and good humor make it possible to achieve a brilliant effect with just a few moments' effort, although this final effect may be far from the first effort spent on that particular passage." If traditional effects are desired, Guedry advises, "the artist must analyze what these effects actually consist of, and plan with procedures that work in acrylic."

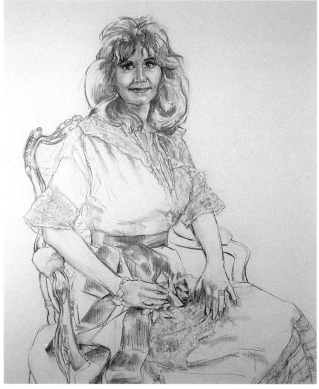

STEP 1

After getting the sitter's approval of a rough drawing, Guedry starts this portrait with a more refined version of the drawing on his support.

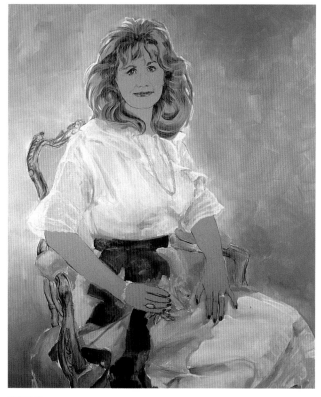

STEP 2

In Guedry's first paint application, he is concerned with the placement of values. The clothing with its shadow patterns is loosely painted in.

STEP 3

The flesh color of the head and hands is painted in flatly and outlined with a red pencil. Guedry next goes over the lines with burnt sienna and burnt umber in the darkest places. The face is exaggerated, and then some lines are painted over with translucent flesh color to subdue them.

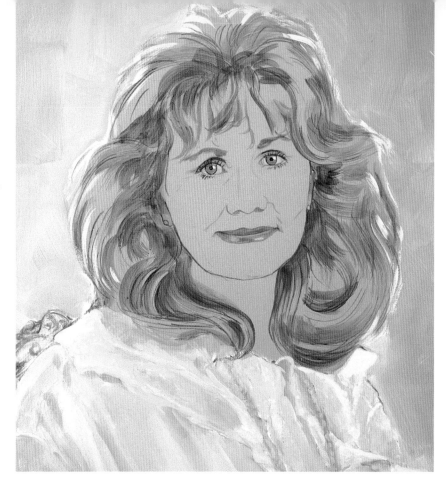

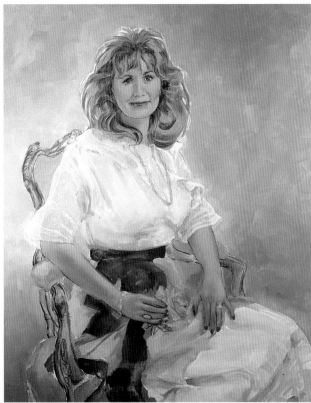

STEP 4

Here Guedry applies his second coat of flesh color. He glazes with burnt umber and then starts veiling the fleshtones with translucent color.

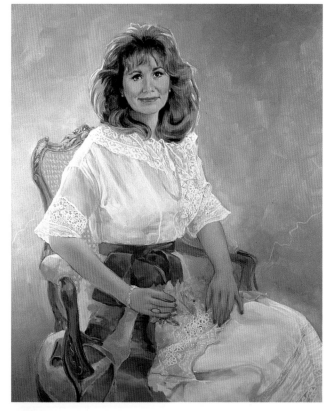

STEP 5

The lace is painted in, and the sash and chair frame are treated with opaque paint. The dark areas of the hair are added, and the middle fleshtone is hatched onto the face.

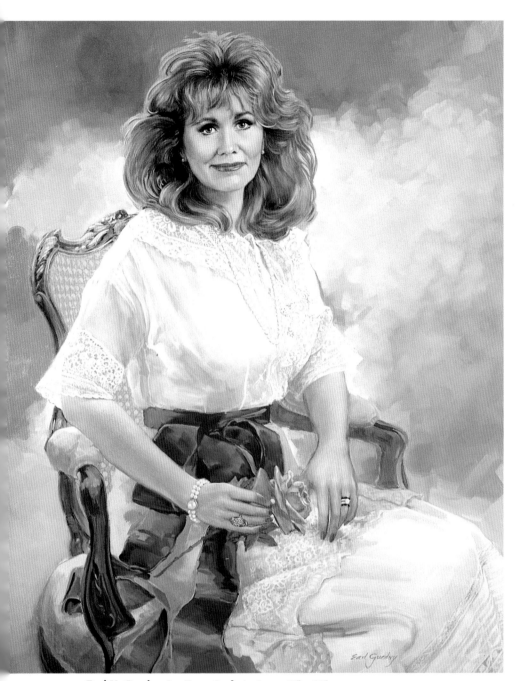

Earl V. Guedry, Jr., **Fran, Lady in Lace**, 40″ × 30″

FINISH. A slightly romantic cast adds charm to the contemporary realism of this portrait.

In these details of the finished portrait, we can appreciate Earl Guedry's achievement of exquisite realism in rendering each of the varied elements.

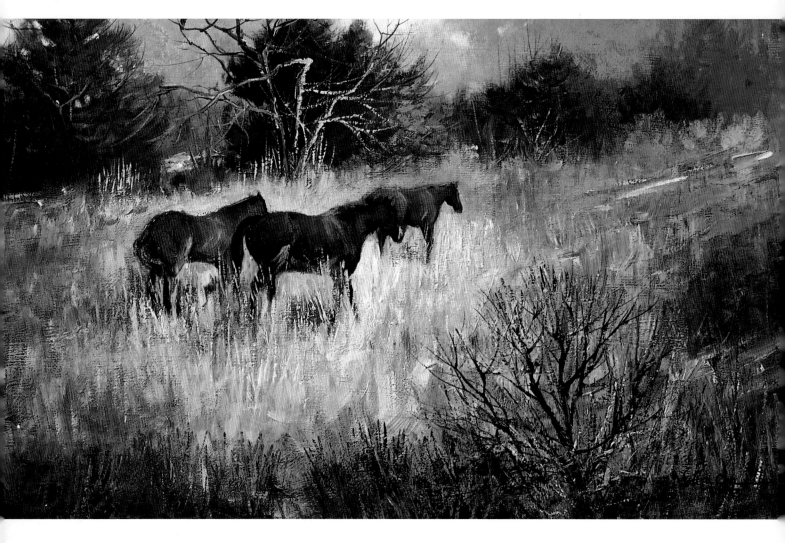

Landscapes: Invention and Imagination

If Joseph Orr were not a fine landscape painter, then he could well be a fine acrylic paint salesman. To list Orr's praises of the medium might easily take up one quarter of this book. In particular, he enjoys finding new materials to move and texture his paint with. Among his collection of "paint manipulators" are paper towels, Saran wrap, sand, plate glass, S.O.S. pads, wood — and a good imagination! If you have just glanced at the illustration of Orr's work on this page, you may feel the urge to do a double take. That such seemingly unrestrained methods can achieve such meticulous and realistic results does amaze!

Orr gave up painting in oil twenty years ago, and has not stood still since, in his search for new applications and additives for acrylics that would facilitate both the painting process and the subtle depiction of beauty. "There is no substitute for practice!" Orr states. "The more acquainted you are with the medium, materials and subject, the easier it is to express your ideas with more professionalism. Experimentation is essential, not only for beginning artists but for the knowledgeable ones, to keep new ideas rising to the surface."

Joseph Orr, **The Wild Bunch,** *12¼" × 22"*

COMBINING BRUSHWORK AND ODD TOOLS. *Orr uses tools such as plastic wrap and steel wool pads to depict flowing water and rock crevices. His horses, though, are rendered almost entirely with brushes. Orr finds a "chisel" brush (bright) is perfect for creating the highlights of the horses' musculature, by simply twisting and turning the brush. The grass is textured with a very small palette knife.*

A Subtle Depiction of Nature's Beauty

PHOTO

When Joseph Orr hikes out with his paints looking for "the picture," he relies first on his intuitive reactions in choosing a spot. Upon further scrutiny, the scene must meet certain requirements: Does it have enough values, hard edges, soft edges and dramatic lighting? If so, he goes to work.

PRELIMINARY SKETCHES

Using L-shaped mattes, Orr re-examines his thumbnail sketches. This helps, he says, "in determining composition and in deciding on the size that the finished painting will be developed to."

ON LOCATION

Working on small supports, Orr quickly does a couple of studies. "Keep it small and quick. First impressions are the best," he says.

STEP 1

Back in his studio, using the thumbnail as reference, Orr sketches his picture on a larger support with a pencil tied to the end of a fishing rod. This device lets him keep his distance from the drawing so he can get the proportions right. He starts blocking in with paint. The arrow on the canvas reminds him where his source of illumination is.

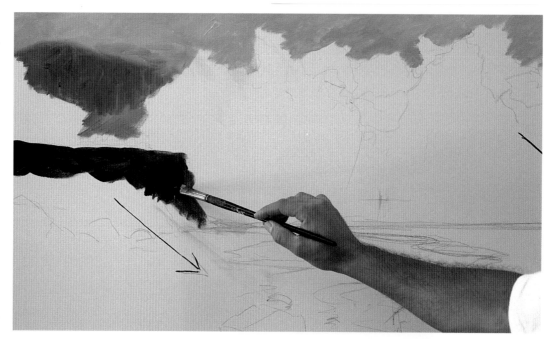

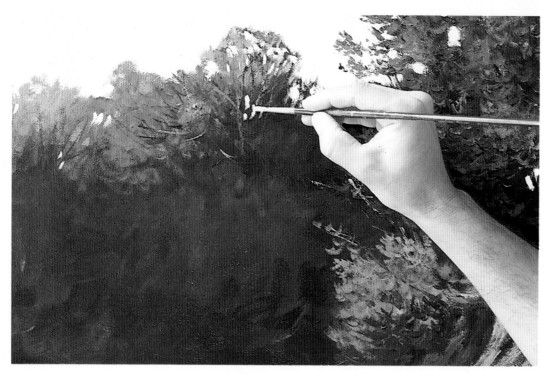

STEP 2

With a palette knife, Orr works the surface of the painting. He uses it to render reflected light on the beach area as well as for textural effects throughout the painting. Using a round bristle brush, Orr develops filtering light between the tree limbs with an application of opaque paint.

STEP 3
As the painting appears to be finished, Orr takes a breather and a review. After some contemplation, he decides that the dark area in the background needs some color to attract the eye.

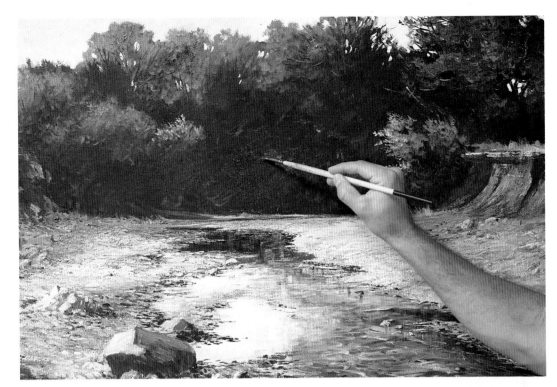

*Joseph Orr, **Summer on Linn Creek**, 24″ × 48″*

FINISH. *Having applied color in the foliage of the shadowed area of the trees, Orr now feels satisfied that the viewer's eye will be guided through and into the painting.*

Painting Nature: The Finished Effects

Another realistic landscape artist is George Goebel. His dramatically staged pictures (as he will tell you up front) take a long time to do, for he is a precise artisan when it comes to finished effects. With his use of blending, stippling, crosshatching, scumbling and semiopaque glazing, the only other medium that would respond to his delicate hand would be egg tempera. This was, in fact, the medium he used some years ago. However, he became disillusioned with tempera because of its fragility in the course of its two-year drying time, as well as the potential problems of mold growth and cracking if the paint was not applied just right.

Goebel's love of acrylic has much to do with its fast drying time. He says: "For me the greatest strength of acrylic paints is the fast drying time, which is roughly a few minutes depending on temperature and humidity. Because my techniques consist of drybrush, scumbling and glazing, acrylic's fast drying time allows me to quickly lay down layers of color. These layers of color may be painted in a semiopaque scumble with a transparent glaze of color over the top of the scumble, without having to worry about the underpainted colors lifting up. Because of acrylic's quick drying time, you can finish a painting one day and put it in an exhibition the next. You can't do that with oil."

*George Goebel, **Ridgewalker**, 25¼" × 40¼"*

KEEPING COLORS CLEAN. *In this painting, Goebel was able to depict the leaf litter of the forest floor with rapid strokes, painting highlights and glazes in a matter of minutes. Acrylic's fast drying time allowed him to apply juxtaposing colors without the hazard of their mixing together and becoming muddy.*

Capturing Nature's Delicate Detail

STEP 1

George Goebel's first step is to cover a ¼" panel of Masonite with six coats of gesso, sanded between layers. He then sketches in the subject with pencil. Next, he applies a very light transparent glaze, which consists of equal parts of red oxide, yellow oxide, water and matte medium. Goebel explains, "It should just be a blush so the gesso shines through. This serves to slightly warm up the background."

STEP 2

The background trees are the first element of the composition to be painted. Goebel accomplishes this by glazing successive layers of color mixed with matte medium and water, starting with white plus a touch of chromium oxide green. Transparent washes of ivory black and then white follow, finishing with chromium oxide green.

STEP 3

The leaf debris on the forest floor is stippled in with an equal-parts mixture of red oxide and yellow oxide. Darker shadows and leaves are painted with a mixture of ivory black and raw umber. Yellow oxide is dappled about for variations in the litter. After the scattered vegetation and the middle-ground trees are painted in, ivory black is thinly glazed over the green to give definition to the bark and branches and, in turn, a final spotty glaze of chromium oxide green is painted over the ivory black to "take the edge off." The smaller trees in the middle ground are painted with thinned-down ivory black.

STEP 4

The large tree is washed with sienna so transparently that the pencil lines show through. The bark is defined with glazes of chromium oxide green, and gradually detailed with washes of ivory black and raw umber, using random stipples and strokes. A dash of sienna is used to show wood rot.

STEP 5 (above left)
The moss on the roots is laid in with a mixture of one part raw umber and two parts chromium oxide green. The foreground leaf litter is depicted with the same techniques and colors used for the middle ground.

STEP 6 (above right)
Goebel completes the moss and ground litter by stippling and glazing opaque and semiopaque values of vivid lime green, followed by light emerald green and cadmium yellow light. The figure is painted in sienna. Using tiny strokes and stipples, Goebel finishes a full-value underpainting.

STEP 7
Now Goebel starts to glaze transparent colors of Payne's gray, ultramarine blue and brilliant blue for the clothing and backpack. The shadows on the white shirt are glazes of chromium oxide green, mixed with white and overpainted with a thin wash of ivory black and ultramarine blue. Everything is then given a transparent glaze of chromium oxide green.

STEP 8 (DETAIL)

Goebel paints in the fleshtones using cadmium red light mixed with white. The shaded areas are glazed with cadmium red, raw umber and ivory black. The hair and beard colors are raw umber glazed over with cadmium oxide green and white, mixed very transparently, with ivory black in the shadows. A touch of yellow oxide and sienna are used in the beard. All flesh and hair is then glazed over with a thin oxide green glaze.

George Goebel, **In an Ancient Place,** *22¾" × 15¼"*

FINISH. *The small, foreground trees are painted white, then glazed over with chromium oxide green, permanent light blue, ivory black and raw umber, with a final glaze of very light sienna. The green vegetation in the foreground forest floor is realized in chromium oxide green, vivid lime green and permanent light blue glazes. Goebel's attention to detail and use of aerial perspective convince us of the reality of this scene.*

Dramatic Landscapes: Using Lights and Darks

Although Mark Jacobson's pictorial matter ranges from landscape to inner-city buildings, his paintings all have a calm foreboding about them. It is not so much the handling of the subject matter that provokes a sense of loneliness, but rather the depiction of a place to be alone in. One could entitle his body of work "Me-scapes."

Jacobson has a command of value as a means of leading the viewer into the picture. The viewer's eye tends to seek the lowest or foremost dark value as a means to enter a picture at the bottom, and travels from there through neutral values until it comes to the lightest. Jacobson places his darkest values in the foreground. The interesting aspect, though, of his control of our eye as well as our mind is that he generally divides his pictorial space into half light and half shade. Once we have entered the picture at the darkest point, we seem very content to stay there as a point of reference from which to view the rest of the picture plane. Thus, we have the sense that we are not standing in front of the picture, but rather in it. The particular emotional response will vary with the viewer, but Jacobson's methodical mastery of this medium using a low-chromatic palette undoubtedly moves us.

Mark Jacobson, **Sentinels,** *14″ × 21″*

PLACE VALUES CAREFULLY. *In this underpainting (the preliminary blocking or washing in of colors, values and shapes), of uppermost importance to the artist are the values. Jacobson makes sure he will pull the viewer into the painting by deft placement of darks and lights, before attending to any details.*

Seascapes: Capturing Mood With Color

Geri Keary has always painted with a sense of relaxation, and this is reflected in her subject matter as well as her style. Loose, liquid-looking strokes of color impart an easygoing atmosphere to her renderings of scenes of tranquil energy.

Mood is conveyed in her work largely through color. Over a basal wash that provides overall harmony, Keary states, "I loosely apply color washes one over the other spontaneously, hoping to convey the beauty and color of my impression of the scene." Variety in the application is also significant. "Variation in line and color adds excitement and helps keep the viewer interested." To embody this philosophy, Keary could not have picked a better subject than boats at rest—assembled with their varying appendages crisscrossing in ordered confusion.

"Before finishing a painting, I add some 'color notes,' as I call them. Maybe a spot of dark or light to help draw the eye to the main interest in the painting. Maybe a little calligraphy, or even a bright color to bring out the main subject more. Sometimes, at that point, there may be something that should be taken out because it does absolutely nothing for the painting, and actually takes away from its simplicity. This is what is terrific about acrylics. Just paint over and take out. When making a correction, I always go back to my original orange-and-white, or whatever I used for my original wash. I block out the area and paint the changes that I need."

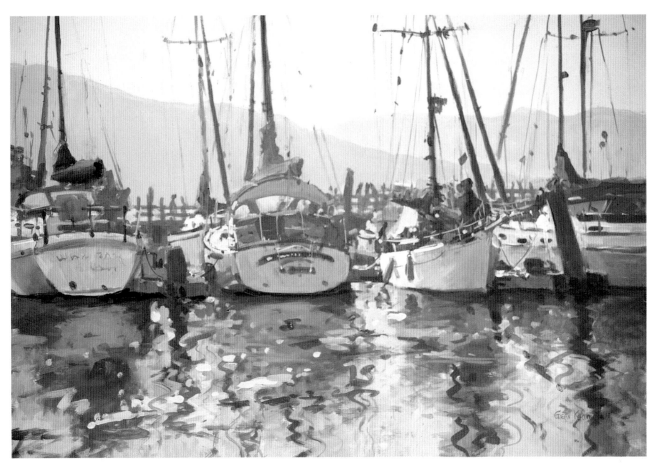

Geri Keary, **Twilight on "A" Dock**, 19" × 29"

CREATING WARMTH AND HARMONY. *Keary begins by washing her 100 percent rag board with orange, which imparts to her painting an overall warmth and harmony. She sketches her composition in charcoal, which she goes over with warm colors (red with a touch of blue). Some of these lines are left showing, giving a certain sharpness to the finished painting. The softness of the background enhances the tranquil mood.*

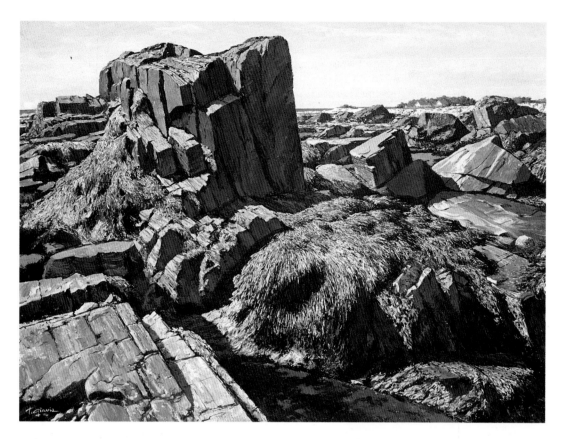

Ted Giavis, **Low Tide,** *29″ × 39″*

A BAS-RELIEF EFFECT. *Giavis's shorescapes are impastoed with a palette knife for an almost bas-relief effect. Dipping the knife into three or four pigments, stirring them slightly and stroking onto the canvas produces strokes with a mixture of colors peeking through what Giavis calls "controlled accidents"—"controlled because I've chosen the pigments, and* accidents *because I don't know how they will appear after the stroke."*

Helen Schink, **Along the Connecticut River,** *14½″ × 21½″*

A WATERY TECHNIQUE. *Schink employs a "watery" technique in creating this waterscape. She begins on wet paper, which throughout the painting process, she mists with water and sprays gently with alcohol to blend and diffuse colors.*

Painting Wildlife: Creative Fun With Fine Detail

Carol Decker's sensitive portrayals of animals in the wild display consummate technical skill and the talent to breathe life into painted images. After years of painting in oil, Decker turned to acrylic as a medium more conducive to her realistic and highly detailed style. For her, the transition was not problematic. "Fortunately, the fast drying time gave me no trouble. I seem to use acrylics very much the same as the oils, with glazes and layering. Off I went to perfect my use of acrylics and enjoy the creative fun they offered."

Acrylic Mediums Add Texture

Part of the fun was in the use of the many acrylic mediums, such as gel, which Decker at times applies for pretexturing the image before painting. In "Handyman Special," an askew nest house in a snowy, wooded setting, Decker says, "I wanted to give the feeling of built-up peeling and chipped paint that has weathered many nesting seasons. I used modeling paste applied to the surface of a gessoed, primed Masonite board, which is what I usually paint on (I like smooth surfaces for detail). Using a palette knife, I just spread it around, sanding if it became too heavy, and simply painted over it, using the surface texture to suggest my direction of cracks and peels. It's such fun to do."

Having dipped into the treasure chest of painting mediums, Decker has discovered countless ways to manipulate the paints. This, in turn, has made necessary the invention of new tools for new application techniques—a topic addressed in chapter six. But, says Decker, the most important ingredient for any artist is "stick-to-itiveness"—a quality each of us must find in ourselves.

Carol Decker, **Handyman's Special,** *12″ × 16″*

KNOW YOUR SUBJECT. *To paint wildlife in its habitat as Carol Decker does, "being a naturalist is really the first career, then painter," as she says. Decker has spent many hours in the field (or woodland or swamp) studying, photographing and sketching animals in their homes and coming to understand the nature of each of her subjects. Decker assures us that the house wren in this painting, for instance, does not mind that its nest box is askew. She has even found a wren building a nest in the pocket of her husband's jeans while they were drying on the clothesline!*

Carol Decker, **First Sunshine,** *18″ × 19″*

RECONSTRUCT NATURE. *On her many excursions into the field, Carol Decker observes, records and does quick sketches in her journals "for the idea." Photos, she says, "can be taken of the background information, whatever the setting, and additional reference can be taken from books," all of which helps her "reconstruct a happening in nature" back in the studio.*

Painting Still Life: Building Opaque Layers

The highly detailed, realistic still lifes of Penny Saville Fregeau benefit from the use of the acrylic medium—as does the artist. Fregeau blossomed under the tutelage of her mother, a portrait painter, learning early to paint in oils. But when she became a mother herself, with her studio space in her home, Fregeau was concerned about the use of toxic materials. She switched to acrylics, and soon realized its advantages over oils.

Because Fregeau paints in thin, opaque layers, she was hindered by oil's long drying time. "Since my works tend to be highly detailed, taking over a hundred hours to complete each painting, the time saved is something I really appreciate."

In addition, "the pure brilliance in color and its versatility make it a joy for a former oil painter."

Carol Decker, **Forgotten Garden,** *16″ × 20″*

FIND INSPIRATION CLOSE BY. *"The beginning painter in acrylics," Decker says, "should keep fun and play uppermost, and just get to know the medium." And, as Decker does here, you may find inspiration in your own backyard.*

Penny Saville Fregeau, **Pasta and Vegetables,** *22″ × 28″*

ATTEND TO LINE AND FORM. *The dramatic and detailed still lifes of Penny Saville Fregeau attest to her philosophy that "line and form are the most important elements." She sees color, too, as "greatly significant," and finds "endless possibilities" in a limited palette.*

Painting the Highly Detailed Still Life

Fregeau takes full advantage of acrylic's opaque abilities, especially in the initial stages of her painting. "I can boldly 'block in' my desired composition, confident that if I change my mind later, this paint's opaque property will not preclude me from redoing part(s) of the painting. I can proceed immediately with the next step, whereas with oils, I would have to stop work for a few days until the painting dried sufficiently, before continuing. This allows a smooth transition in my working and affords me the opportunity to make changes at any time."

Because Fregeau relies so heavily on thin, luminous layers so that color shows through color, the ability of acrylic to be "thin" and yet durable is the perfect answer to Fregeau's needs. If an area of the image she is working on needs blending, she will mix glycerin and water in a spray bottle and apply it to that section to retard the drying time of the paint. All in all, Fregeau says, "In both my still life and figurative works, the need for opaqueness, luminosity, blendability and high detail is well supplied by the use of acrylics."

STEP 1

To nail down the composition, Fregeau starts with some preliminary sketches. After she is confident about the overall look, she enlarges the drawing, paying little attention to details to leave room for spontaneity.

STEP 2

Fregeau rapidly blocks in her darkest darks and lightest lights. At this stage, she wants to be sure the painting will catch the eye by means of contrast and drama.

STEP 3

Now Fregeau starts blocking in local color. "Local color," she explains, "is the actual color of the object in natural light. Since the true color of an object (what we see with our eyes) is determined by the light that hits it, the local color may actually be only a small part of the finished object." With the local and middle values established, Fregeau can now get a better idea of the composition and color harmony. She can begin to add some "color fullness" to the blocked-in colors.

STEP 4

As Fregeau becomes more involved with the painting, she becomes dissatisfied with the angle of the clock. She says, "I make the correction, bringing the bottom-left corner of the clock down behind the tie. Since I have painted in a smooth manner, covering up the discrepancy is not a problem, as acrylics can be used in an opaque state." Painting thinly with a swirling motion, she applies more details and gives the sky a wash that lends it a more "atmospheric look."

STEP 5

Now Fregeau paints in the details of the doily with a small brush and turns her attention to the perfume bottle: "In order to make the edges of the crystal and the etched portions of the vase look convincing, I need a brush that softens the edge of the paint. I use a Grumbacher 4720R Bristlette that has been worn down by continuous painting. The bristles have been worked down to ¼" long and a chiseled, pencil-type point."

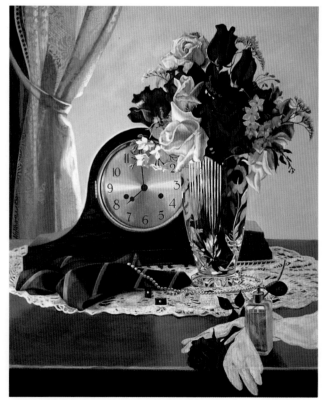

STEP 6

At this point, Fregeau says, "I feel something more needs to be added to the composition. I find a pair of soft white gloves. Setting up a table in my studio, I set up the gloves, perfume and lighting. When the gloves are 'blocked on' to the painting, I also change the center of interest by adding a table edge. More detail is added to the crystal."

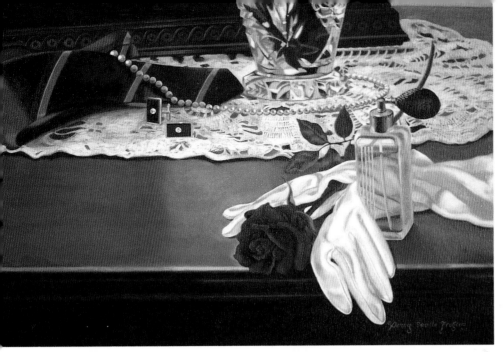

DETAIL

Fregeau gives some final attention to the gloves as well as to the cuff links. She comments, "All the details in the painting are added to and scrutinized. The overall ambience the painting gives is what I want to communicate. The painting is finished."

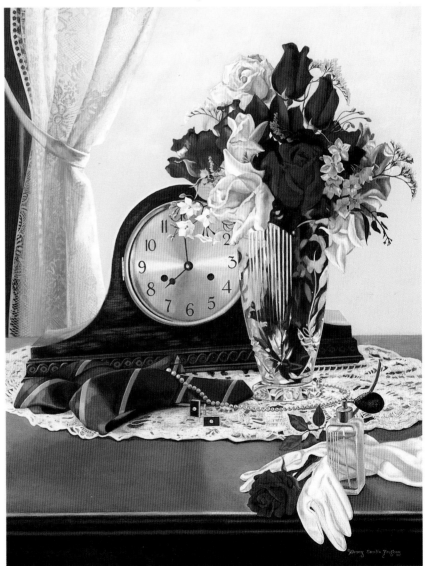

*Penny Saville Fregeau, **When a Man Loves a Woman**, 26″ × 20″*

An Alla Prima *Approach to Painting Still Life*

In contrast to Fregeau, Pamela Coulter Blehert approaches her still lifes with a broader, down-to-earth touch, grouping objects in scenarios that convey comfortable domesticity. And whereas Fregeau likes to build her colors up in thin, opaque layers, Coulter enjoys an *alla prima* approach, laying her pigments on in a single application. She paints on various papers and boards, finding the tooth of canvas an impediment to the quick and vigorous manipulation of her paint.

"Set" Your Drawing

Aware of acrylic's amenity to change and correction, Coulter jumps right in without a preliminary drawing. After "posing" the elements of her still-life model, she sketches out shapes with charcoal and works them to the best advantage of space, tension and harmony. To "fix" the charcoal, Coulter applies a light coat of matte medium or thinned white glue over the lines, slightly smearing or "integrating" the drawing. "Don't overdo this," she cautions. "You just need to set the drawing so you're not muddying the colors later." After a final check, Coulter decides whether the composition gives her the green flag to paint, or the red one to re-gesso her support.

Add Translucent Layers

Translucent layers may be part of Coulter's painting process, in which the structuring of color is an important element. "I may want successive layers of paint in an area to be close in hue. I normally create neutrals on the palette, rather than by layering on the paint surface. If I lay an orange on a blue, both will be duller. On the other hand, interesting effects can be achieved by coming back over an area that was painted with a cool blue shade and glazing with a warm blue shade, and then allowing parts to show through. In this way, the image starts to get more depth."

STEP 1

Pamela Coulter Blehert starts with a pencil sketch on a gessoed matte board. Ignoring any detail, she works up major shapes with charcoal, keeping the drawing simple and flowing. With a no. 12 flat, Coulter applies a 50 percent solution of matte medium over the drawing to "fix" it.

STEP 2

Coulter now starts to block in transparent colors, which are mixed with a large proportion of matte medium. To keep any colors from getting out of hand too early and appearing to be garish, she will add a complementary hue to dull the color.

STEP 3

Before the layers of paint have a chance to build up, and while the board still has some tooth, Coulter will use Venus watercolor pencils and Eagle Prismacolor white to help define areas and keep the loose "drawing" quality of the piece. "The watercolor pencil has to go on fairly early in the development of the process before the acrylic medium makes the surface impermeable. Keep two things in mind if using watercolor pencil: When you go back over with medium, the color will darken, and the colors may be more fugitive and decrease the archival quality of the piece," she says.

STEP 4

Still maintaining her transparent passages and looseness of line, Coulter attends to her finishing details. In the jade plate, for instance, she defines the values in the leaves and in the background, dulling the light area a bit to push it back. This can be done with a semitransparent, grayed white. "I scribbled into the white overlay in the left background," Coulter says, "to echo the scribbled quality caused by pencil in the still life and to integrate the 'feel' of the piece."

Pamela Coulter Blehert, Mangoes, *16" × 20"*

FINISH. *Coulter uses an old toothbrush to replicate the spatter pattern on the mangoes. Then using a fine 0 brush, she brings more definition to the jade. "Coming back in quickly with a no. 10 'shader' by Cornell for the flat, round shapes of the leaves, I smooth the blue cloth and unify it by thin glazes. Since I had darkened the light area of the background, I darken the shadow thrown by the jade pot."*

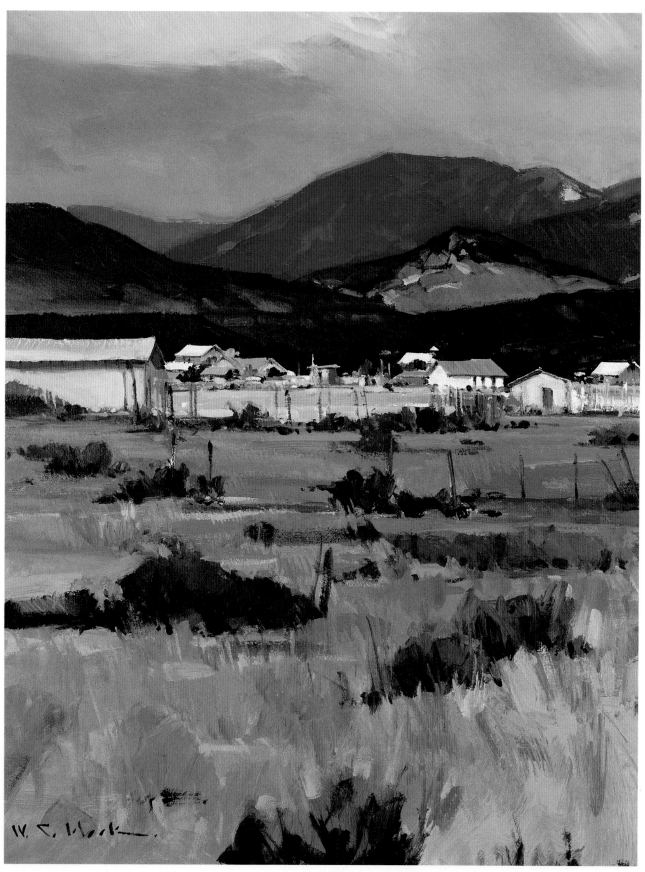

William Hook, **Valley Floor,** *30″ × 40″*

Your paintbox is now burgeoning with tools and techniques. You've ambled down the garden path, and now it's time to smell the roses — without getting snagged on the thorns. Here you'll find some helpful hints on the specialized tools and techniques that will clear the path for a satisfying and successful painting process. Our artists will provide insights on the methods they've adopted for achieving special effects — techniques for collage and mixed media, tricks for adding texture and "calligraphy," and inventive tools for creating varying effects — all ways to get the most from your tools, the medium and the additives.

The last bag of tricks is a satchel of first-aid techniques for "mistakes," common peeves, pitfalls, blunders and boo-boos — helpful hints to hang onto when you feel you need to be rescued. As an artist, however, it's important to be open to experimentation and to welcome mistakes as a learning tool. Happily, in acrylic painting, there's virtually nothing that can't be fixed. And for many potential problems, a little preventive medicine is the best bet.

Insiders' Tips

Secrets to Special Effects and Cures for Common Pitfalls

More From the Mediums

The acrylic additive mediums can liven up your painting process in all the ways described in chapter two—and more. They are useful in texturing, ease of correction, collaging, and even in transferring design or pictorial elements to your painting surface. The varnishes and gel mediums, for example, can be used to build up a foundation from lightly textured to "bas-relief," on which the paints can then be applied. Helen Schink, who paints in both abstract and realistic styles, often starts off with such a textured surface, applying a wet layer of anything from a varnish to the thickest gel. Various tools (from an ordinary brush to a household broom) can be used to develop textural effects in the medium. In addition, any of the varnishes or gel mediums are excellent adhesives for applying collage elements to your painting. Schink collages with bits of old paintings torn into various sizes and shapes, tissue paper, and all sorts of Oriental papers that may also be painted before collaging with them. Their varied textures, Schink says, "are marvelous for collaging rocks, fruit and water areas."

As a foundation, Schink finds gloss medium useful as well. "When gloss medium is painted on the paper before the actual painting process begins, the artist finds it easier to lift colors, if desired." Experiment with mediums and also, Schink says, "with different papers and boards. Texture and the amount of sizing used in the manufacturing will cause different effects when painted on. Experiment with as many types as you can, to find the one that suits the type of work you do."

ADDING A TEXTURED WASH
Then, after applying a thin blue wash over the black shape, Schink rolls toilet tissue over the wet areas to make new shapes within the larger form. Through a variety of creative techniques, a dramatic landscape is materializing.

MAKING MAJOR CHANGES
Not only corrections but major transformations are possible. When Helen Schink decided to take this work-in-progress in a new direction, she collaged over it with tissue paper covered with gloss medium.

A NEW LOOK
After more tissue, Schink applies paint, working up mountains in blue and black and a white snowfield. "Slashes" of black from a palette knife bring drama to the foreground. "Spritzes" of water and alcohol diffuse the colors.

Carol Decker, Phoebe Nest, 14" × 18"

USING A POLYMER TRANSFER. *Carol Decker explains:* "On this painting I used a polymer transfer for the little box in the background on the beam. Using a copyright-free picture from a book, magazine or one of my own images, I coat it several times with gloss medium, drying between coats. After soaking in water and rubbing until the paper is removed, the ink stays in the medium, producing a plastic transfer that can be adhered to any surface with more gloss medium. The transfer is not reversed using this method. The possibilities are unlimited for enhancing a painting or collage."

Mixed Media

Applying other media to your acrylic painting can be a lot of fun. Arne Lindmark and Dean Mitchell, as we've seen, combine acrylic with its aqueous cousin, watercolor. Helen Schink will use glue—especially as a calligraphy tool—as well as ink, charcoal, crayons and colored pencils to emphasize the textured areas of her work.

Brad Faegre also encourages painters to dip into other toolboxes. "I have used acrylic colors often enough in conjunction with permanent inks, soft pastel and colored pencils that I can recommend experimentation with these combinations. I mix media at those times when one material alone cannot express an idea to my satisfaction.

"Pastel, colored pencils and permanent ink can be incorporated before, after or throughout the painting process. However, one note of caution: On areas saturated with pastel where no support is exposed and available for paint to adhere, paint may resist the pastel and bead up. However, persistence with the brush will usually win over the pastel."

Brad Faegre, The Studio, 9" × 9"

ADDING PASTEL PENCILS. *In this small study of a corner in his studio, Faegre began by sketching with pastel pencils. He then applied acrylics in a loose fashion, and came back with the pastels to further define and emphasize certain objects and areas.*

Household Potpourri

The inventive artist is by no means limited to the equipment in the art-supply store. Whenever my wife and I go grocery shopping, I somehow get lost in the housewares department, searching eagerly for who-knows-what—anything from feather dusters to scrubbing pads may catch my eye. The mop in my closet, the cornflakes in my cupboard, the twig in my backyard may all come in handy in the studio.

Helen Schink enjoys using plastic wrap, foil, tissue and toilet paper in her work. She will lay one of her "tool elements" into the paint as it is drying to create varying effects.

Joseph Orr relies on such implements as paper towels, plastic wrap and steel wool for texturing, a very important element in his work. Such materials—and others, like nylon screen, sandpaper, sponges and cardboard—can be used by patting, scraping, rubbing or pressing into the wet paint and then lifting off.

Plastic wrap or newsprint, for example, can be applied either flat, crinkled or crumpled, and then removed, for different effects.

Wildlife artist Carol Decker finds that "snow is a joy to do with acrylics. Spattering with a small toothbrush works wonderfully. In addition, I use toothpicks, cottons swabs, leaves, sticks, fingerprints, a small spray bottle with thinned paint—anything that will create a texture I'm after.

Try These Painting Tools

mop	toothbrush
plastic wrap	spray bottle
cornflakes	fingerpaints
twig	leaves
foil	cotton swabs
tissue paper	newsprint
toilet paper	toothpicks
paper towels	cardboard
steel wool	sponges
nylon screen	sandpaper

Earl Grenville Killeen, **Odalisque**, 40″ × 30″

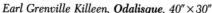

Photo: Erik Redlich

TOOTHBRUSH SPATTER
Spattering paint with a toothbrush over a painted surface can produce optical mixing of colors, add texture or create an effect such as snow or sand.

USING UNUSUAL TOOLS. *In learning to get comfortable with acrylics, I abandoned my traditional brushes and used only a stencil brush and any kitchen tool I could find. The wood texture here was accomplished with a ridged scrubbing pad.*

Masking Without Mess

At times you may need to cover a portion of your picture to protect it while applying paint to a nearby section. For this, masking will do the trick. It can also be used to create shapes or edges. Masking tools include sheets of frisket, liquid frisket and white artist's tape. The self-adhesive frisket sheets, often used with airbrush painting, are cut to shape, affixed and later peeled off. Liquid frisket can be applied with a brush of the appropriate size, and removed by rubbing with the fingers or a pencil eraser. Tape is the method I prefer for creating the flowing lines and circles so prominent in the machinery I like to paint.

Masking Curves

To mask curves, I take a length of ¾" tape and run it down a 4' piece of glass I keep next to my easel. I then run a blade down the length of the tape twice, so I am left with three sections. Because of the thinness of the tape, it easily stretches and curves to my requirements. After placing it on the support, I will apply widths of ¾" tape to protect against overflow.

Removing the Masking

After completing my passage, I waste no time in removing the masking, in case of leaks. These are not a problem if handled quickly. Since the tape protects the paint from the drying air, any excess can be promptly wiped off with a wet paper towel.

Masking should always be removed as soon as possible, with caution—especially if you did not use a medium in your paint mixture, or if you used an excess of water. Under those conditions, the tape may pull the paint off the support. If you wish to remask the area, wait about half an hour to be sure the paint is sufficiently dry.

Photo: Erik Redlich

MASKING
This photo shows not only acrylic's hard-edge potential with the use of masking tape and liquid frisket, but also its facility for making lines. The fine line in the center was accomplished with a drafting stylus on a medium-toothed surface.

Photo: Erik Redlich

MASKING A CURVE
I probably use more masking tape than paint when I do a picture. On this one, I used up three rolls. Tape can be used alone or to hold down a mask of paper or waxed paper.

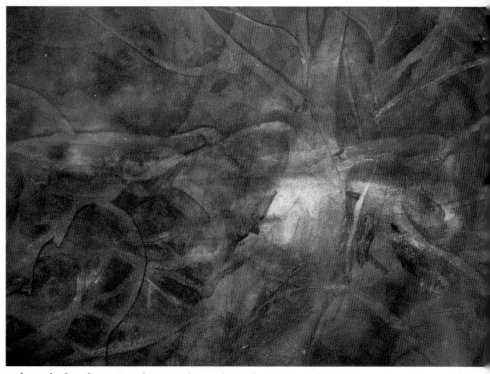

*Helen Schink, **Of Tree Trunks, Branches and Boughs**, 14½" × 14"*

WAX RESIST. *Another masking technique is wax resist. In this painting, Schink says, "I took a candle and rubbed it on the paper in various places. Then I applied the paint, one glaze after another, and the waxed places stayed white—resisted the paint—forming branches."*

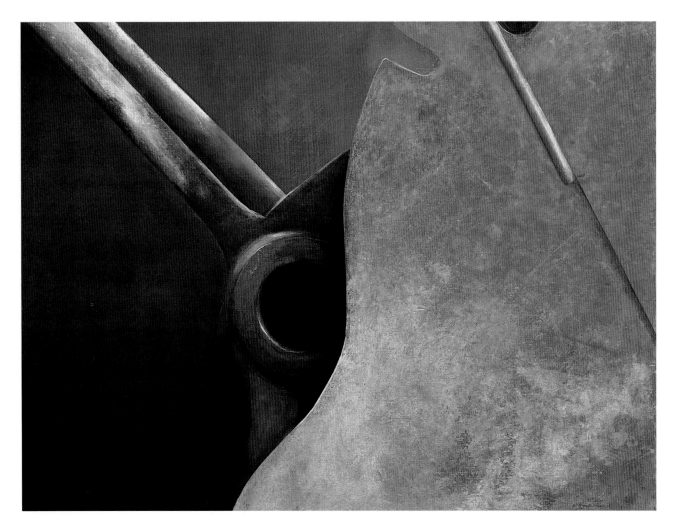

Blending Tricks

Acrylic's fast drying time admittedly makes blending on your support no easy matter. Without a plan or some tricks at your fingertips, you may well be frustrated by hard edges and stark transitions between colors and values. A variety of tools and methods make blending manageable, and different artists use different techniques to suit their styles and purposes.

Generous Amounts of Paint

Some artists, like William Hook and myself, approach the challenge of blending by applying excessive amounts of paint to the support. This helps to prolong the drying time and allows you to manipulate your adjacent colors into a blend. After you

scrape off the excess paint, the result may or may not be exactly what you desired, but working in acrylic often entails a building up of repeated applications to achieve an effect. Remember that each application will dry quickly, so the whole procedure will be relatively fast.

Adding Adjacent Body Color

Another approach for avoiding hard edges in transitional areas is suggested by Earl Guedry. "When an area is first painted with opaque color, it is often helpful to add some of the adjacent body color near the edge of the area being painted and blend it in. Do the same when the other area is being painted also. If an undesirable hard edge does

Earl Grenville Killeen, **Eops,** *37″ × 48″*

MASKING AND BLENDING. *Planning and timing are key elements in both masking and blending. In this depiction of the side view of a bulldozer, I did a lot of my blending in the early layers, using an overly generous amount of paint and scraping off the excess. (Later on, I can do quick glazes for finishing touches.) As far as masking, I don't even bother until I have applied at least five to six coats of paint. This gives me a faster drying time for the next layers so that my masking-and-painting process is less hampered by waiting time.*

appear, a faux blend can be quickly managed by mixing one or several intermediate blends of the two adjoining colors and applying lines, thereby grading one color to the next." If one color is very much higher in value or intensity than its neighbor, covering more of it with the lines of grading will keep it from appearing to grow in size.

Hatching

"*Hatching*, or small vertical lines," Guedry explains, "can be used in small areas to give a sharply controlled shading that would be very difficult with direct blending. Paint thinned with water, applied with a small, pointed brush in an easily achieved rhythm can cover surprisingly large areas. Since the paint will go down in value when dry, it is easier to control hatching light-over-dark, as the final effect is exaggerated while it is being done."

Feathering

Feathering is similar to hatching in its blending effect. It is done with a fan brush and stiff paint by drybrushing a bit of a color over the color adjacent to it, and vice versa. Laura Anderson uses fan brushes a lot for blending as well as scrubbing, particularly in small areas of the painting. She often has trouble finding brushes small enough, so she trims down new ones to a smaller size by snipping the bristles on each side of the fan. Also, she says, "I extend the life of all my fans by cutting across the top of the bristles, trimming away uneven ends."

BLENDING WITH BRUSH

For blending, the wider the applicator, the softer the transition and the greater the possible range from hue to hue or value to value in subtle gradations. A moist, wide, flat brush will serve well; and for even larger coverage, a paint roller dipped in colors laid out on a glass palette can quicken the application. The effect you want may require repeated strokes.

Photo: Erik Redlich

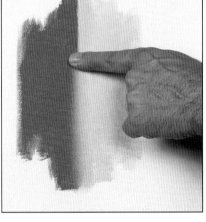

BLENDING WITH FINGER

Some very good and clean blending can be done by butting two colors or values next to each other and running your finger down the middle. Compared with a brush, however, this process gives you a more dramatic intersection, suitable for rendering a softly-lit corner, perhaps. Again, you might find it necessary to do more than one application.

Photo: Erik Redlich

BLENDING WITH PALETTE KNIFE

A good tool for controlling a blend, and probably a timesaver, too, is a palette knife. You can use the knife to apply a very generous amount of paint and then to remove the excess and smooth out the blend (if desired).

Photo: Erik Redlich

*Helen Schink, **Nautilus**, 14" × 19"*

A MIXED BAG OF TRICKS. *Helen Schink employs a mixed bag of tricks for blending. Here, after drawing the nautilus shell on paper with a brush dipped in ochre paint, she sprays the whole thing with water and lets it dry. Then she applies an ochre glaze, and as it dries, she blots with tissue before applying a blue glaze. A small brush creates the roundness of the shell, and a toothbrush spatters blue, ochre and sienna on the rocks and sand surrounding the shell "so it all becomes one form."*

Blending With the Brush

Brushes are useful for smoothly blending not only colors, but values and large, background areas. Once you learn and practice a few tricks, your brush will be ready to perform "magical" transitions. To blend colors, I dip one corner of my wide, flat no. 8 or no. 10 brush in a color to the halfway mark. Then I dip the other side of the brush into the other color until the two colors join at the middle. I run the brush on the support several times until the paint runs out or starts to dry, and I may repeat the procedure more than once. For even smoother and more controlled blending in the middle of the stroke where the colors come together, I like to rub the paint with my fingers.

I have a slightly different method for blending values. First, dip your brush up to the ferrule in the lighter value. Using your fingers and a paper towel, pinch off the paint from the lower half of the bristles and dip into the darker value until it mingles with the lighter in the middle of the brush. Starting with just enough pressure to release the dark value, make your stroke firmer as you go, aiming to reach the end of your passage just as the ferrule starts to hit the support. Repeat your stroke without redipping, adjusting the pressure if necessary to get the darks and lights just where you want them, until the paint gets tacky. With a little experience, you can put several values on your brush for a subtle gradation. To blend and soften edges with transparent color, I find stenciling brushes work best.

Painting Large Backgrounds

For large backgrounds that have gradations in either color or value, some painters rely on retarder to slow drying time or on airbrushing, but I prefer a well-planned, bristle-brush strategy.

*Laura Anderson, **Red Chairs, Decisions**, 12" × 12"*

FEATHERING. *Blending can also be done by feathering, as Laura Anderson does here. Her technique of soft layering with fan brushes allows her to make smooth transitions of light and shadow on a relatively small support. In this depiction, she wanted to confine the chairs to a constricted space, using the space and lighting to create a sense of mystery.*

1. I mix all my colors and values in advance, using about a dozen mixing cups and making sure to have adequate amounts of each mixture. (You don't want to get caught short in this process.)

2. Using a no. 8 or no. 10 synthetic, flat brush, I begin at the lowest point on the support with my lightest values.

3. To make the gradation, I wipe the brush clean, dip it into the next value, and stroke, overlapping the first value by the width of my brush.

4. Quickly and thoroughly cleaning the brush to remove any trace of the first value, I continue using mostly horizontal strokes while progressing upwards on the support to where the next transition in value will occur.

5. Then I take a clean brush (no. 10 or house-painter's) and, starting at the bottom, run it back and forth, slowly moving up to the point at which I'd left off.

6. Moistening the brush with a mixture of gloss medium and water, I go back to the bottom and work up again. These procedures smoothly blend the seams between colors or values.

7. The top seam will have become somewhat dry by this point, so I take that same value and butt it to the top passage, working it slightly downward before moving upward again.

8. The process progresses in this manner until all the premixed cups have been used.

In this way, I've done backgrounds forty inches high, gradating from (for example) green to midnight blue. It will take several repetitions before a look of uniformity emerges. But as the tooth of the support fills, the paint becomes slicker and the grading process is easier.

Linda Kooluris Dobbs, **Water Street, Edgartown,** *28" × 22"*

NO TACKY BLENDING. *Linda Kooluris Dobbs reminds us that blending can be done wet-into-wet or wet-over-dry. But it is in the period in between, when the paint is tacky, that any attempt at blending entails the risk of streaking or cratering.*

Aiding the Eye

Aids to visualizing help artists locate promising subject matter and view work in progress from an advantageous perspective. One easy-to-make visual aid is a pair of L-frames. Joseph Orr uses this tool when he ventures out to make studies for his pictures. Holding two L-shaped pieces of matte board between his eyes and the scene to create a frame, he blocks out distracting elements and hones in on what catches his eye. By adjusting the frame, he determines how the composition and proportions of the subject matter will translate to the painting. I use L-frames similarly, but in the studio, with photographs that I've taken in the field.

Stand Back From Your Easel

Another tool Orr uses is not found in the art-supply store. In order to draw or paint on his support and at the same time be able to view his work as a whole, Orr attaches a pencil or brush to the end of an old fishing rod and stands well back from his easel, where he can work with his eye on the total effect.

Using Mirrors

If your studio (like mine) can't accommodate you and an easel *and* a fishing rod, there's an alternative: two cheap mirrors, one face-size and one larger (such as full-length). If you place the smaller mirror next to your support, facing you, and the larger mirror about six feet in back of you, when you wish to view your painting from a distance, you need not get up. Just look into the small mirror and you will have a view of your reflected painting as though it were twelve feet away.

Using a Camera

And as for the camera, a very handy visual aid—why should any of us be defensive about using it judiciously as a tool? Cameras have been used by artists since the Impressionist period, and as early as the Renaissance, the use of a crude camera, or opaque projector, was common. If there was a tool or device available to the artist to make his work simpler, then it was used.

Though I might wish for more direct contact between myself and my subject, I'm thankful to the camera for bringing into my studio a reference file of my own personally garnered materials for use regardless of the weather or lighting conditions. In any case, what I paint can't pose for me indoors. Just try asking a contractor if you can borrow his sixty-ton excavator for the weekend!

L-FRAMES
Joseph Orr uses L-frames to help him find a suitable-for-painting bit of a scene in the field. Also, as we see here, they become adjustable borders on his studies—aids to determining the focus and dimensions for the enlarged, finished painting.

REFERENCE PHOTOS
Although all artists know that the camera lies, it does come in handy when your subject can't come to you. But use photos only for reference, relying instead on your memory, imagination and drawing skills to compose and create your art.

DRAWING FOR *TED ON THE PLOW*
Robert Bissett has the technical skill to render a highly realistic image of his subject. The photos he uses are not snapshots that he copies but deliberately composed reference materials that he adapts to his aesthetic vision. Notice, for example, that the horizontal photo becomes a vertical painting and that distracting elements have been eliminated. See the finished painting on page 67.

The Foibles of Color

As I said earlier, for some potential problems, a little preventive medicine is the best bet. Getting acquainted with the performance of acrylic colors will avoid possible disappointment.

Acrylic paints don't behave in exactly the same way as the "same" colors in other media. Using a color chart can help instruct you, and experimentation is also a good teacher. "Beginners should not be put off by the flatness of the first few layers," Laura Anderson advises. "You can begin to control the luminous quality of the paint from a flat base" as you build layers.

Matching Wet and Dry Color

A particular pitfall, as Earl Guedry describes it, is the fact that "the acrylic mediums themselves are not transparent until dry. This means that glazes and veils will not show their final effect while they are being manipulated, and all the colors will drop slightly in value upon drying." So, it is tricky to mix a color to match one that has dried on the painting. The solution is to lay a wash of clean water over the dry paint on the support. This will approximate the hue and value of the paint when it was wet, and serve well as a guide for mixing. Even if the color is a little off, the effect can generally be corrected by glazing over the entire area of the painting with the new color.

Because matching mixtures *is* a little tricky, it's a good idea to prepare plenty of each color on the palette or in containers so that you don't run short. I often use any left-over paint for priming my next canvas—or I simply throw it away. The loss, which amounts to pennies, is small compared to hours of potential frustration.

Earl V. Guedry, Detail from **Alice**

REMIXING A COLOR. *If you run out of a color you've mixed, it may be difficult to remix a color to match. Mismatched colors can give your work a patchy look. To avoid this, mix ample amounts of each color; or in a pinch, as Earl Guedry suggests, wet the color on the painting to help guide you in mixing, as he did for the reddish bits of fur.*

Photo: Erik Redlich

PAINT WITH GEL

When mixing paints, any of the gel additives will (1) "stretch" your paint; (2) make the paint more transparent; (3) retard the drying time; and (4) reduce the intensity of the color that can be built up by glazing. However, it's a good idea not to "jump into the gel without checking the depth"—that is, the thickness. Premature application of thick texture can turn into a headache later in the painting process. It's advisable to start with thin applications onto which heavy texture can be built, if desired.

Troubles With Texture

Texture can add wonderful dimension and interest to a work, but unwanted bits of texture can be devastating. Such a setback can occur when your brush picks up bits of dry paint from your cups or palette and leaves them on an otherwise-smooth painting surface. If you catch the flecks while the paint is still wet, you can gently lift them out with your finger or a knife, and retouch the passage. But keeping your paint mixtures free from dried flecks is, again, an ounce of prevention.

Avoiding Ridges

Equally frustrating, and probably more common, are the ridges that can occur when using flat brushes or masking tape. Either of these tools can leave you with a fat edge of ridged paint, which in most cases, is not a desirable effect.

When I use a flat brush, I often pinch the paint from both corners of the bristles with my fingers. As the brush is run across the support, the paint will spread out from the center of the brush and lightly fill the squeezed-out edges, leaving a uniform passage of paint. If ridges are still appearing, you can take a clean, dry brush and pass it over the ridge, being careful to incline the brush toward the middle of your passage to avoid contaminating neighboring colors.

When you mask with tape, any paint that is applied alongside the tape (whether with a brush, knife or any other tool) will form a ridge that will remain after the tape is removed. This ridge can be manipulated with a palette knife rather than a brush, but again with deliberate movements *inward* along your passage.

Using Unforeseen Textures

Unwanted ridges must be dealt with immediately, before the paint gets tacky, especially if you are working with a palette knife. The knife will gradually and greedily grasp drying particles of paint, collecting them to the central portion of the blade's surface. As the blade is drawn over still wet paint, the particles will cause scarring and gouging.

Earl Grenville Killeen, Detail of Eops

SMOOTHING RIDGES. *In this painting of rusting machinery, each of the straight or curved edges was masked with tape. When the tape was removed, residual ridges of paint had to be carefully smoothed with a palette knife.*

But—eureka! You may decide to do this very thing intentionally, transforming a pitfall into a technique, with which you can create a marvelous drybrush effect. Or, such an area of scratching or pitting can be glazed over with a darker color and then wiped clean, leaving the pits and scratches filled with the darker paint for a striking textural treatment. Helen Schink's words might be apropos here: "Don't get discouraged if one picture in your mind doesn't turn out on paper. Often something quite unforeseen happens that is better than what you hoped would happen. Enjoy!"

Tacky, Tacky

But whether you are looking for a finished effect that is textured or flawlessly smooth, whether you're painting with a brush, your hand or a floor mop, it is important to be sensitive to the drying of the paint. Through experimentation, you'll find the limits of the paint's tolerance for manipulation. There is a split second between wet paint and tacky paint. And once the paint is tacky, working it can easily cause erosion not only of the layer you're working on but also of the one below as well, if it is not thoroughly dry. This can result in a "crater" in the middle of an otherwise beautiful passage.

The tackiness pitfall is one of the reasons I like to paint almost exclusively with my hands. I do not have to rely on my vision to detect the slight scarring that tells me the onset of tackiness has begun. Rather, the feel of the paint under my palm or finger tells me when to back off before any damage can be done.

*Earl Grenville Killeen, Detail of **Dances With Buffaloes***

EXPLOITING PITFALLS. *Perceptions about pitfalls ride two tides. One way of reacting to a "mistake" is to reject the unintended. Another way is to be delighted with the discovery of a new technique. A case in point is the pitting or scuffing of the paint due to working it past the point of tackiness. This could be disastrous; but in my series of pictures depicting rusting metal surfaces, the effect is often welcome. Here I used two tools: the palm of my hand for clear, smooth passages of glaze, and a palette knife for deliberately pitting the more corroded areas of my subject.*

The Time Factor

One of the most challenging processes in acrylic painting (as we saw in chapter six) is blending on the support. Working your brush over the fast-drying paint, you think, "Oh, no! Do I have enough time?" The sensation is perhaps something like what you might feel on laundry day when your mother-in-law drops by unannounced. Once the door is opened, you (and the unwashed piles) have no time to hide. But relax—you don't have to be polite to your paint.

Repeat, Don't Erase

Anything you do on the support can be undone. And nine out of ten times, it's the process of repeating rather than erasing that will work to bring about what you want to see. In the process of repeating and building up layers of paint, you'll find that the drying time for your working layer is slower, giving you more time to blend. Patience with yourself as well as with your materials will go a long way.

Also, as Pamela Coulter Blehert says, "*Unlearning* other disciplines is handy. Someone coming from another discipline should be prepared for a certain amount of experimentation without preconceived ideas of how it should look. Specifically, the artist or art student who *has to have a product* is most liable to be frustrated by the encounter. I've done some gosh-awful acrylics . . . still do occasionally." As Blehert suggests, getting into the *process* is where the satisfaction lies; and, along the way, we *all* make mistakes, small or large.

Penny Saville Fregeau, Detail of **The Welcoming**

USING A RETARDER. *Using a retarder such as glycerin and developing a rapid painting method are two ways of "beating" acrylic's fast drying time. Penny Saville Fregeau does both. She says, "To have a smooth surface is very beneficial (especially since I paint multilayers in acrylics). Learning to achieve smooth transitions in color takes practice. I've developed a rapid scumbling motion with my soft brushes to achieve the needed softness and gentle tonal transition."*

Now About Those Mistakes

Almost every artist who's contributed to this book has expressed something like George Goebel's philosophy: "The best way for an aspiring painter to succeed at this medium is to experiment and make mistakes. I've learned more from making mistakes than almost anything else, because when you mess up, you begin inventing. A beginner in acrylic painting should try landscape, portrait and still life, because each category comes with its own set of challenges. Don't be afraid to make mistakes. Sometimes mistakes can turn into happy accidents."

Sometimes mistakes "work," and sometimes they have to be fixed. "Some famous teacher said that

a painting is a series of corrected mistakes," Robert Bissett states. "I'm running with that. To improve a painting, you must be willing to make mistakes, even big ones. You may have heard that the difference between a good carpenter and a bad one is that the good one knows how to hide his mistakes. The same is true for artists. You must experiment. When an experiment fails, as they often do, try something else. Acrylics allow you to work through this cycle quickly and safely even in large areas with major changes."

Is It Really a Mistake?

Before you set out to "correct" a mistake, step back and ask questions: Is it a *mistake* just because it is not what I intended to do? Is it actually a mistake, or have I not gone far enough yet? Do I want to stick this thing in the attic and just start over? Actually, this last

extreme is rarely necessary, as mistakes can be handily dealt with at any stage of the painting process.

If the paint is still wet, an errant stroke or a misplaced color or shape can be rubbed off with a finger or cloth. If a wayward drop or splatter lands on a dry portion of your painting, just wipe it off promptly with a wet paper towel.

Removing Dry Paint

But what if you don't catch that drip until it has dried? Or maybe you find some detail just didn't turn out right. For small areas, dried paint can be removed with alcohol on a cotton swab, or can be scraped off with a craft knife or a single-edged razor blade.

Making Large Changes

Suppose you need to make large changes. Joseph Orr explains that "if the painting has not yet been

*George Goebel, **My White Oak in the Moonlight**, 28¼" × 41⅜"*

CORRECTING THE SKY. *"Don't be afraid to make mistakes" is George Goebel's philosophy. Goebel first added too many stars in this painting. He corrected this by matching the sky color and filling in with a detail brush. Acrylics are correctable whether wet or dry, and even after varnishing, with such tools as a wet sponge or alcohol or sandpaper.*

*Earl Grenville Killeen, Detail of **Dances With Buffaloes***

*Brad Faegre, **Between Storms**, 24" × 36"*

PAINT AND REPAINT. *Corrections can also be done by painting over what you don't like. Brad Faegre considers acrylics "a very forgiving medium. If you make a mark and you are not pleased with what you see, wait a moment for it to dry and try again. Time is not the enemy with acrylics. I prefer to think of the fast-drying characteristics of the medium as an invitation to paint and repaint, until you see something you like."*

WARMING A COLOR. *Near the conclusion of this painting, I decided that a small, dark (purple) seam between the components was too cool. I did not want to lose the color so much as the temperature of the color. Mixing a small amount of gloss varnish with a dot of raw umber, I glazed (or veiled) over the purple to produce a warm version of a cool color. See the finished painting on page 84.*

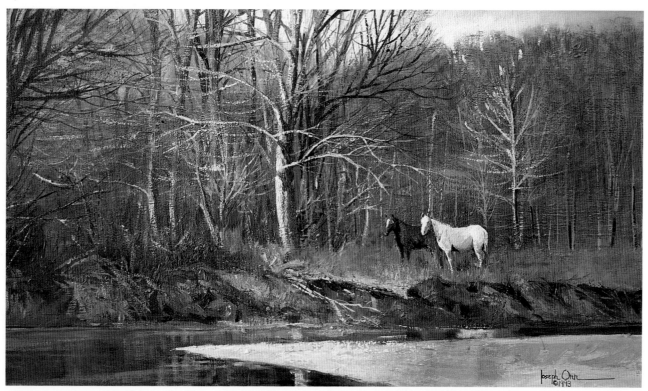

*Joseph Orr, **Osage Sand Bar**, 12¼" × 22"*

CORRECTING OVER VARNISH. *Making corrections after a painting has been varnished is more difficult. Alcohol on a cotton ball will remove acrylic varnish little by little, but the difficulty is in retouching the varnish. The same is true if you have used gloss or matte medium varnish; you can make corrections on the varnish itself, but it will be necessary to revarnish the entire painting, as Orr did here.*

varnished, it is easy to make corrections. Basically, you just paint over the area after the paint is dry. This can be accomplished by glazing with a transparent or semiopaque veil of color or by 'painting out' an area with opaque white or gesso and repainting. In the case of making a correction over a textured area, I use a very fine sandpaper to restore a smooth working surface before making a correction."

Corrections After Varnishing

Orr continues, "Once the painting has been varnished, either by brush or spray, it is harder to make corrections without affecting the surface of the painting. Acrylic varnish is removable with alcohol on a cotton ball, going over small areas at a time. When the varnish has been removed and the alcohol is dry, I make any corrections over the existing paint.

"I have found that corrections *can* be made *on top of* Liquitex gloss-medium varnish, but the entire painting must be resealed with varnish upon completion. Interesting and useful effects can be achieved when painting over spray varnish. You will get a bubbled or noncoagulated effect, but again, the painting must be sealed with more varnish afterward."

Anda Barbera, **A Moment in Summer,** *24″ × 36″*

A JOURNEY OF EXPLORATION. *The path of learning to paint with acrylics can take you out into your surroundings with a new eye, and can lead you also on an inward journey of exploration. Whichever direction you travel with your acrylic palette, the prospects are bound to be enticing.*

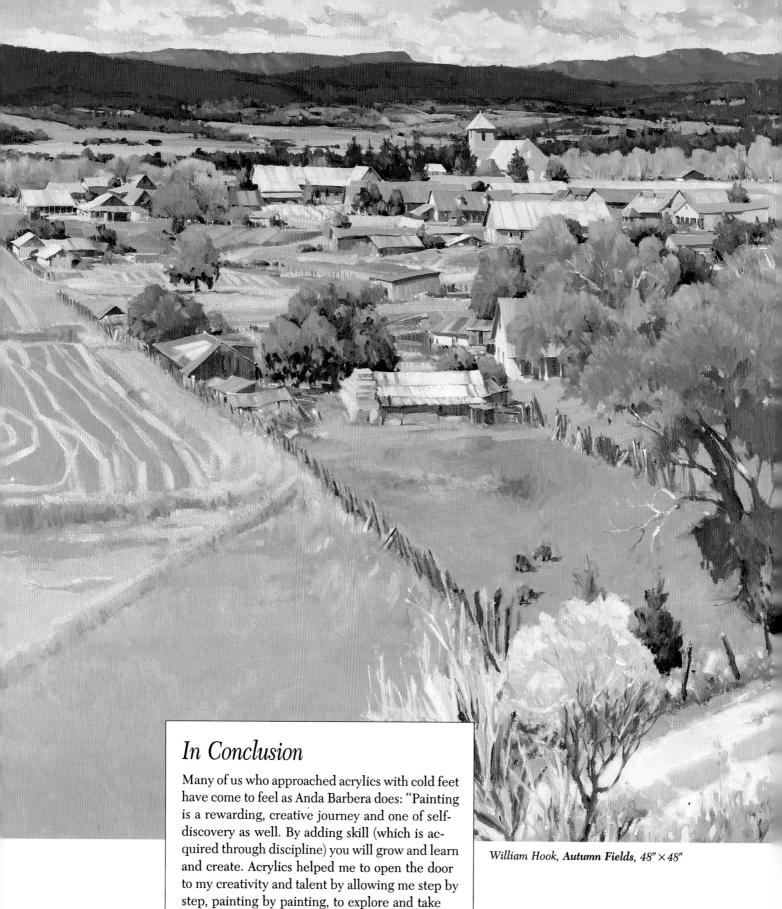

In Conclusion

Many of us who approached acrylics with cold feet have come to feel as Anda Barbera does: "Painting is a rewarding, creative journey and one of self-discovery as well. By adding skill (which is acquired through discipline) you will grow and learn and create. Acrylics helped me to open the door to my creativity and talent by allowing me step by step, painting by painting, to explore and take risks. I always knew if I did not like what I had done, I could simply paint it over, and that gave me the confidence to try."

*William Hook, **Autumn Fields**, 48" × 48"*

accenting: using small strokes of relatively dark color as a "finishing touch."

aerial perspective: the use of gradations of color, value and degree of detail to convey a sense of distance in painting.

bright: a brush with a flat ferrule, short bristles and a square-shaped end.

chroma: color saturation in combination with hue.

crosshatching: fine, closely spaced lines overlapped by similar lines at right angles.

drybrush: a technique in which fairly "stiff" opaque color is lightly drawn across the painting surface with a brush.

fan: a brush with spread hairs and a flat ferrule.

filbert: a brush with a flat ferrule, medium to long bristles, and an oval-shaped end.

flat: a brush with a flat ferrule, long bristles and a square-shaped end.

glazing: the application to a painted surface of a transparent or translucent layer of pigment to modify the effect of the existing colors.

ground: an absorbent medium applied to the support to serve as a painting surface.

highlighting: using small strokes of white or a light color as a "finishing touch."

hue: specific color, such as red or yellow.

impasto: the application of a pigment to a support in a way that is thick and/or heavily textured.

masking: using frisket, tape or another material to protect part of a work in progress from stroked, spattered or sprayed paint, or to create hard-edged lines or shapes.

medium: 1. materials used for artistic expression, such as oils, watercolors or acrylics. 2. a liquid that is mixed with painting pigments.

opaque: impervious to light; not transparent or translucent.

palette: 1. a surface on which a painter mixes pigments for application to a painting. 2. the colors that are laid out on the palette. 3. the range of colors used and the manner of their use by a particular artist.

round: a brush with a round ferrule and pointed tip, with bristles of varied lengths.

saturation: purity of hue.

scumbling: applying a thin coat of opaque or semiopaque color in a manner between glazing and drybrushing; the effect might be described as a "broken glaze."

support: the material surface on which a painting is done (such as canvas or paper).

value: the degree of lightness or darkness of a color.

veiling: glazing with a translucent wash of color to darken or lighten existing values or to blur or soften areas that are too strong.

More Great Books for Oil and Acrylic Painters!

Painting with Acrylics — 25 full-color step-by-step demonstrations will show you how to tackle a variety of subjects from the figure to portraits and more!
#30264/$21.95/176 pages/paperback

The Complete Acrylic Painting Book — You'll master the techniques of working in this beautiful and versatile medium with 32 detailed demonstrations and loads of helpful advice.
#30156/$29.95/160 pages/256 color illus.

The Acrylic Painter's Pocket Palette — 1,632 color mixes will help you pick the perfect mix without wasting time or paint! Each swatch shows you a dry glaze, a 60-40 mixture, the mixture tinted white and applied as a watercolor wash.
#30588/$16.95/64 pages/4-color throughout

Enrich Your Paintings with Texture — Step-by-step demonstrations from noted artists will help you master effects like weathered wood, crumbling plaster, turbulent clouds, moving water and more — in any medium!
#30608/$27.95/144 pages/262 color illus.

Enliven Your Paintings with Light — Sharpen your light-evoking abilities with loads of examples and demonstrations.
#30560/$27.95/144 pages/194 color illus.

Strengthen Your Paintings with Dynamic Composition — Create powerful, memorable paintings with an understanding of balance, contrast, and harmony.
#30561/$27.95/144 pages/200 color illus.

Dramatize Your Paintings with Tonal Value — Make lights and darks work for you in all your paintings, in every medium.
#30523/$27.95/144 pages/270 color illus.

Energize Your Paintings with Color — Create a sense of drama and emotion within your paintings as you master the use of vivid color and brilliant light.
#30522/$27.95/144 pages/230 color illus.

Welcome To My Studio: Adventures in Oil Painting with Helen Van Wyk — Share in Helen Van Wyk's masterful advice on the principles and techniques of oil painting. Following her paintings and sketches, you'll learn the background's effect on color, how to paint glass, the three basic paint applications, and much more!
#30594/$24.95/128 pages/146 color illus.

Timeless Techniques for Better Oil Paintings — You'll paint more beautifully with a better understanding of composition, value, color temperature, edge quality and drawing. Colorful illustrations let you explore the painting process from conception to completion.
#30553/$27.95/144 pages/175 color illus.

Bringing Textures to Life — Beautifully illustrated step-by-step demonstrations will teach you how to add life and dimension to your work as you render dozens of textures in oils.
#30476/$21.95/144 pages/500 + color illus./paperback

Painting Flowers with Joyce Pike — Popular artist/instructor, Joyce Pike, will help you make your florals absolutely radiant with 240 color illustrations and 15 demonstraions!
#30361/$27.95/144 pages/240 color illus.

Foster Caddell's Keys to Successful Landscape Painting — You'll paint glorious landscapes with practical advice from this master painter. Plus, dozens of helpful hints will help you solve (and avoid!) common painting problems.
#30520/$27.95/144 pages/135 color illus.

Basic Oil Painting Techniques — Learn how to give your artwork the incredible radiance and depth of color that oil painting offers. Here, six outstanding artists share their techniques for using this versatile medium.
#30477/$16.95/128 pages/150 + color illus./paperback

Painting Landscapes in Oils — Master painter, Mary Anna Goetz shows you the methods and techniques she uses to paint landscapes alive with light and color.
#30320/$27.95/144 pages/200 colorillus.

Oil Painting Develop Your Natural Ability — No matter what your skill level, you'll develop you own style as you work through 36 step-by-step exercises with noted artist, Charles Sovek.
#30277/$29.95/160 pages/220 color illus.

Joyce Pike's Oil Painting: A Direct Approach — As an oil painter, you know that one of the biggest problems is keeping colors clean and pure. Joyce Pike shows you how to overcome this problem and paint more beautiful oils.
#30439/$22.95/160 pages/190 color illus./paperback

Painting the Beauty of Flowers with Oils — You'll get clear, insightful instruction on everything from effective use of materials to choosing flowers. Plus, you'll see handy tricks used to tackle the most troublesome parts of still lifes.
#30325/$27.95/144 pages/195 color illus.

Oil Painter's Pocket Palette — Full color reproductions of an array of color mixes will help you choose the perfect colors to convey a sense of tone, mood, depth, and dimension.
#30521/$16.95/64 pages

Capturing Radiant Color in Oils — Vitalize your paintings with light and color! Exercises will help you see color relationships and hands-on demonstrations will let you practice what you've learned.
#30607/$27.99/144 pages/222 color illus.

Painting with Passion — Discover how to match your vision with paint to convey your deepest emotions. With step-by-step instructions, fifteen accomplished artists show you how to choose a subject, and use composition, light and color to suffuse your work with passion.
#30610/$27.95/144 pages/225 color illus.

How To Paint Trees, Flowers & Foliage — You'll create balanced scenes full of wonderful greens as you learn to keep foreground flowers from dominating, represent a tree without painting every leaf, and more!
#30593/$27.95/144 pages

How To Paint Living Portraits — Make your portraits come alive! 24 demonstrations show you great techniques for all mediums.
#30230/$28.99/176 pages/112 illus.